The Art of
POLYMER
CLAY

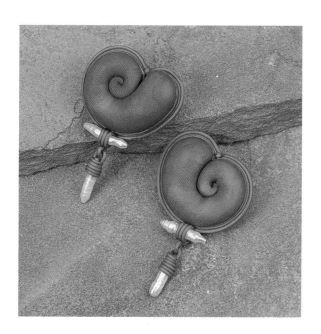

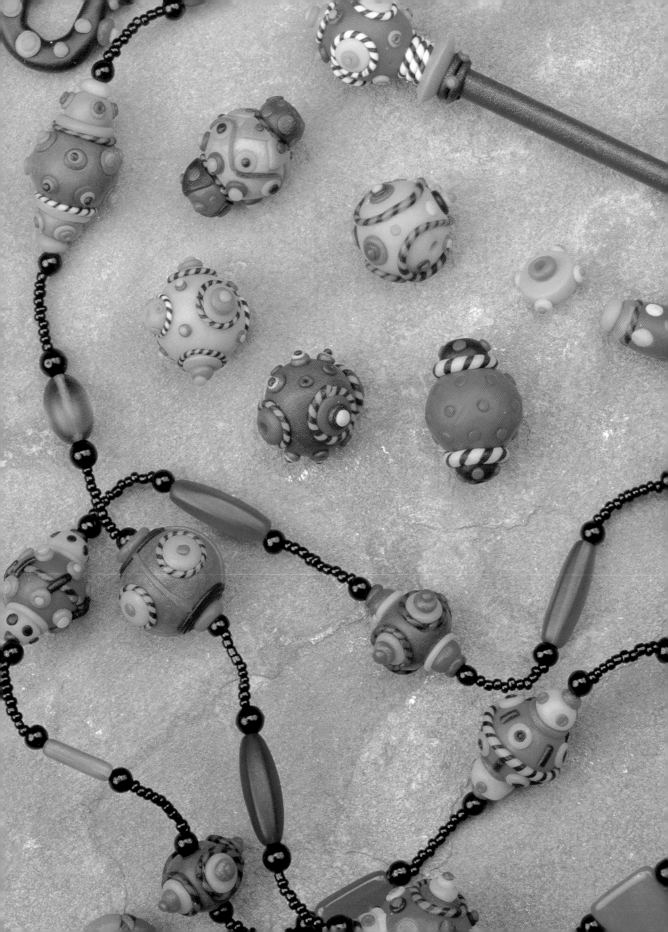

UPDATED WITH NEW INFO
ON CLAYS & TOOLS

The Art of
POLYMER
CLAY

*Designs and Techniques for
Creating Jewelry, Pottery,
and Decorative Artwork*

Donna Kato

WATSON-GUPTILL PUBLICATIONS/NEW YORK

For Mom, Dad, and Vernon,
with all my love and thanks.

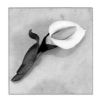

Senior Acquisitions Editors: Candace Raney/Joy Aquilino
Project Editors: Amy Handy/Katherine Happ
Design: Areta Buk/Thumb Print
Production Manager: Hector Campbell

Copyright © 2006 by Donna Kato

First published in 2006 by Watson-Guptill Publications,
a division of VNU Business Media, Inc.,
770 Broadway, New York, NY 10003
www.wgpub.com

ISBN-13: 978-0-8230-0357-0
ISBN: 0-8230-0357-4

Library of Congress Control Number: 2005936620

Manufactured in China

First printing 2006

1 2 3 4 5 6 7 8 / 12 11 10 09 08 07 06

Acknowledgments

This book would not have been possible without the assistance, support, and encouragement of the following individuals.

Watson-Guptill senior acquisitions editor Candace Raney, without whom this book would not exist. To developmental editor, Joy Aquilino, thanks for your patience, serene presence, and extraordinary organizational skill. Thank you, Amy Handy, for whipping the project together and tying up all the loose ends. Thanks, too, to Areta Buk for the simple, elegant design of *The Art of Polymer Clay*.

For gifts of friendship, inspiration, and encouragement, I'd like to thank Kathleen Dustin and Nan Roche. You share and give and set the best example for all of us.

The following manufacturers helped immensely through generous contributions of products used in this book: Polyform Products, Kemper Enterprises, Dockyard Model Company, Forsline and Starr, and Houston Art & Frame.

To my best friends, Terri Silverstone, Mary Prchal, Gwen Kato, and Helena Brown—thank you for all the years of laughs and tears.

Thank you to my siblings, Alan, Tina, and Mark. What can I say—we made it!

And finally, thank you, Mary Studebaker, who found Fimo and *The New Clay* and renewed my interest in this amazing and versatile material.

Contents

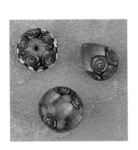

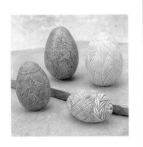

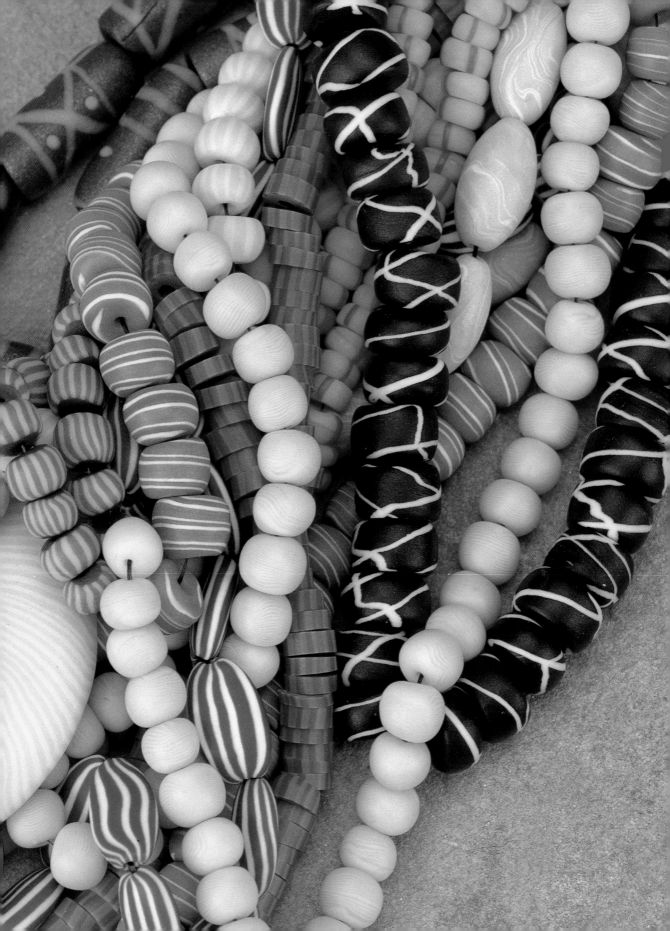

Introduction

Since the release of *The Art of Polymer Clay* in 1997, we've seen many changes in the world of polymer clay. Some of the products that I used are no longer produced and some of the companies I worked with are no longer in business. As those products and companies vanished from the landscape, others arose, offering different possibilities. In this edition of the book, corrections have been made where necessary but the projects remain the same.

The biggest change for me occurred in 2000 when, with Van Aken International, Kato Polyclay entered the scene—yes, I am the Kato. The projects and techniques in this book were originally made using Sculpey III, but they can all be completed with Kato Polyclay, Fimo, and Fimo Soft. These days, I only use Kato Polyclay.

My vision is worse, my hips are wider, and what were once a few scattered grey hairs are now taking over. Some things, however, haven't changed in the least. I still have the same passion and love for this amazing medium. It is still the most exciting and versatile medium in the world of art and craft. The possibilities are still there—make it and bake it.

Polymer clay can still be made to simulate a variety of natural materials and can be used to create the most realistic dolls, sculptures, and prototypes for casting. With minimal shrinkage (less than 1%) cured pieces are permanent and will not return to their soft state. As a heat set medium (not air dry), polymer clay is usable almost indefinitely when stored in a cool, dry place.

Polymer clay is still a great adapter of techniques borrowed from other disciplines. Mold it, carve it, stamp it, drill it, paint it, and sand it. You are only restricted by your own imagination and willingness to "push the envelope." Let the pushing begin!

(Opposite) Multicolor beads constructed in a variety of shapes demonstrate the medium's versatility.

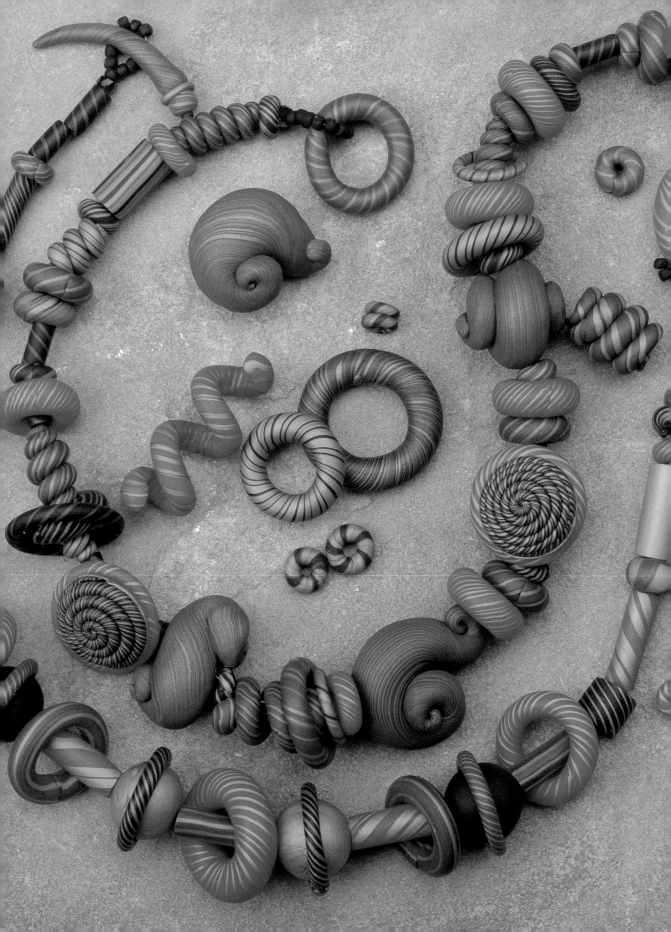

1 | Polymer Clay Basics

(Opposite) Jewelry is perhaps the most popular use for polymer clay, but beads certainly needn't be limited to simple round or oval forms. Swirls, spirals, doughnuts, and twists are all easily shaped with this medium. (Above) Slices of brightly colored millefiori canes were pressed over base beads.

With its vivid colors, ready availability, and tremendous versatility, polymer clay has become one of the craft world's most popular mediums. Its wide range of applications and ease of handling make it ideal for use by anyone from the beginning crafter to the experienced artist. This chapter lays the groundwork for working with polymer clay: basic materials, supplementary supplies, handling characteristics, shape formation, and safety guidelines.

Polymer Clays

Although there may be differences in the way each brand of polymer clay handles, all brands are composed of the same basic ingredients: resins, plasticizers, colorants, and various fillers. Of all the polymer clays produced today, those produced by four manufacturers are the most widely distributed in the United States: Kato Polyclay (USA), Fimo (Germany), Polyform Products (USA) and Cernit (Germany). I began my career using Cernit, moved to Polyform Products, then to Fimo and finally, my own clay, Kato Polyclay. The projects in this book were made with Sculpey III—a clay I no longer use. Your personal preference might be another brand; generally speaking, that brand may be substituted. If desired, you can mix together different brands. I suggest trying as many of the available brands as possible so you can see which you prefer and when.

KATO POLYCLAY

Released by Van Aken International and myself in 2000, Kato Polyclay was formulated to address the needs of artists. It is the most durable and least likely to break of all the brands. Unlike other brands, the color shift from

Available in seventeen colors, Kato Polyclay was created to address the specific needs of polymer clay artists.

raw to cured is minimal. Even with extensive handling, the clay does not become overly soft or sticky.

Van Aken uses state-of-the-art vacuum-extrusion technology that removes air from the clay mass—making the clay denser than the other brands. It is the only clay that can be safely cured at temperatures of 275 to 325 degrees Fahrenheit. From its seventeen-color palette, virtually any color can be created.

Kato Polyclay is an excellent general-use clay, and one of the best (along with Fimo) for creating millefiori canes. Kato Polyclay canes cut with minimal smearing and flattening. Because of its strength and the fact that it does not "plaque" (half-moon shapes in the clay), it is ideal for figure work and very thin items such as postcards and bookmarks.

EBERHARD FABER

Within many circles, the word "Fimo" has become synonymous with polymer clay. Manufactured in Germany, by Eberhard Faber, this opaque clay is distributed in the United States by The American Art Clay Company. Fimo is available in a wide range of extremely opaque and highly saturated colors, in 65-gram bars and in various assortment packs. Fimo is primarily used in making jewelry and figurines as well as in home décor. Eberhard Faber also markets a doll clay called Puppen Fimo, and a softer version called Fimo Soft.

Fimo is the most difficult polymer clay to condition. Fimo users often utilize food processors (with an extra bowl and blade for clay use only) and devices to warm the clay to expedite the process. Exceptionally stiff clay can be softened with the addition of MixQuick (a product offered by Fimo), or with a few drops of Kato Clear Medium or Sculpey Diluent. Fimo Soft is easier to condition than Fimo but can become very soft and sticky. In my experience, Fimo is very strong and stable over time while Fimo Soft becomes brittle and loses its tensile strength.

On the positive side, Fimo is an excellent millefiori caning clay. The opacity of the colors ensures that detail and color separation will hold through the smallest reduction. In addition, when it is sanded and polished the clay takes on a glass-like sheen. As outlined in the millefiori chapter, however, other factors—including packing methods and the individual's skill at reducing canes—ultimately affect the success or failure of a cane.

POLYFORM PRODUCTS

Polyform Products makes Sculpey and Polyform, Super Sculpey, Sculpey III, Premo, Granitex, and Sculpey Flex clays.

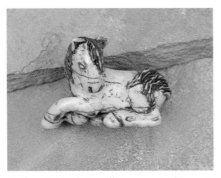
Sculpey III sculpts well, as seen in this netsuke horse.

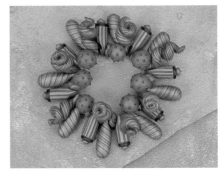
Strung on elastic, these beads were made of both pearlescent Promat and gold Promat mixed with regular colors.

Introduced to the American art materials and craft markets in the mid-1960s, Sculpey and Polyform are actually the same product, sold under two brand names in an attempt to gain recognition in both markets. Available only in an opaque white, Sculpey/Polyform is easy to condition, a characteristic shared by almost all of Polyform's clays. It is not particularly strong due to the high percentage of filler material used in its production. Bulk-packaged in 2-, 8-, and 24- pound sizes, the Sculpey brand is widely used in school art programs around the country.

Super Sculpey is a translucent pink beige color and was formulated for the doll market. It is easy to smooth and sculpt and is a bit stronger than Sculpey and Polyform. Sculpey III has been marketed as a clay for the children's market and it is produced in a wide array of colors. Like Sculpey, Polyform, and Super Sculpey, Sculpey III is weak and brittle, therefore, most items will not stand up to handling. Granitex is actually Sculpey III with the addition of fibers to imitate stone. Premo is Polyform Products' premium clay. Available in a wide range of colors it is stronger than the other Polyform clays but it is not consistently durable. With handling, uncured Premo tends to become overly soft and sticky, making it difficult to handle.

Of all the clay brands, the Polyform clays are the easiest to condition and the clays blend easily when used in an additive manner.

CERNIT

Manufactured in Germany by T+F GmbH Company, Cernit is available in 65-gram packages in a variety of colors, including pearlescents and a glow-in-the-dark color, all of which are translucent. Cernit's translucence can create the effect of additive synthesis, whereby two adjacent colors are merged by the eye and perceived as a third color. For example, original (translucent) white and black clay, placed side by side, will appear as gray. Cernit's translucent quality can be capitalized on to produce delicately beautiful objects.

Cernit is not much used as a sculpture medium but is widely favored by dollmakers for the greater realism afforded by its translucence. Since Cernit

does not blend easily when used in an additive manner, dollmakers frequently roll out thin sheets and then place them over a sculpted form.

While Cernit is much easier to condition than Fimo, it can become overly soft and sticky. Working on a cool surface, such as marble, will help to keep the clay cold. Cernit's stickiness is not an entirely negative characteristic, however, since it adheres to itself extremely well. After curing, Cernit is the hardest of all brands, buffs to the highest sheen, and is stronger than Premo and Fimo. Cernit also retains some flexibility in thin areas, making it a good choice for pieces with delicate details, since the delicate areas will tend to bend rather than break.

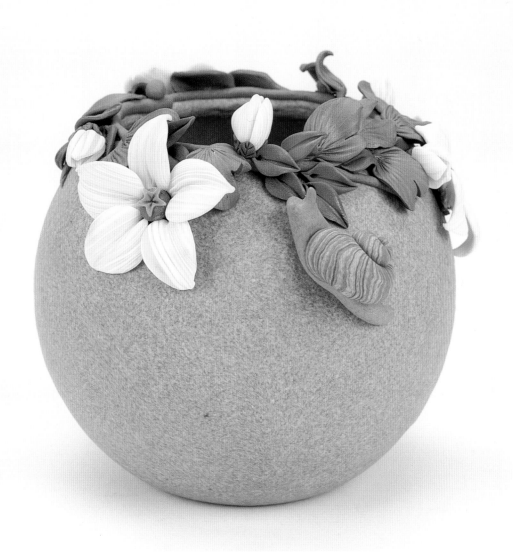

Granitex is ideal for textured-look home decor items. A glass bowl covered with brown Granitex was then adorned with Sculpey III flowers, leaves of green Sculpey III mixed with gold Promat, and a snail made of Sculpey III combined with Granitex.

Tools and Supplies

The finest tools available are your own two hands, but there are many others highly suitable for use with polymer clay. Many tools are "borrowed" from other disciplines, including cooking, ceramics, dentistry, woodcarving, leatherworking, and sculpture. In short, don't be afraid to try anything (within reason) with your clay! There are certain plastics that react with the clay (they melt with continued exposure), so make sure to clean your tools quickly. The tools featured in this chapter are the ones I have found most useful in my own work. As you begin working with this medium, you're bound to find many more.

CHOOSING A WORKSURFACE

I think of worksurfaces in two categories: primary and secondary. My primary worksurface is what I do most of my work on. Because I use Kato Polyclay, which falls into the stiffer category of clays, I use Formica. Formica tends to remain temperature neutral and it doesn't get very cold. The lightly textured surface is also an advantage, as clay lifts easily from it. If you work with a soft and sticky clay like Premo, a cooler surface such as marble might be a better choice. Other worksurfaces to consider are acrylic boards and glass cutting boards. My secondary work surfaces are ceramic tiles and deli paper. Some techniques benefit if clay sticks to the surface and that's when I use small glazed ceramic tiles. Conversely, when I want to work a piece and then easily remove it from the worksurface, I use deli paper—peeling the paper from the back of the clay when I have finished with it. Do not work directly on fine wooden surfaces, as the plasticizer in the clay could damage the wood finish.

Your primary clay should dictate your worksurface. Cool surfaces such as marble or glass work well with soft clays; for stiffer clays, choose a warmer material like Formica or Lucite. Be sure the surface is flat and free of texture.

USING YOUR HANDS

Kneading, smoothing, rolling, and shaping your clay, pressing in here, drawing out there—your hands can do it all. This is a tactile art: get into the feel of the clay.

Keeping your hands clean and uncontaminated as you switch from one color to the next can be problematic, so whenever possible try to work with the lighter colors first before moving to the darker tones. When you're ready to clean your hands, rub them with cold cream or baby oil, wipe them with paper towels, and then finish with soap and water. An alternative cleanup method is to dissolve the clay off your hands by wiping them with paper towels that have been dampened with isopropyl alcohol, and then wash them with soap and water. I keep a package of baby wipes handy for quick cleanup. Isopropyl alcohol is ideal for general clean up duties.

MIXING AND CONDITIONING TOOLS

The conditioning process generally begins with exposure to low levels of heat and pressure. For clays such as Cernit and those manufactured by Polyform Products, the heat of your hands and the process of kneading or rolling through the pasta machine are usually sufficient. Clays that are stiffer require different strategies. To condition Kato Polyclay and Fimo Soft, begin by slicing the block in half. Set half aside. Flatten and compress one half with an acrylic rod until the piece is just a bit thicker than the thickest setting of the pasta machine. Roll through. Continue folding and rolling the sheet through (fold on the rollers or perpendicular to the rollers) until the sheet is soft and pliable. To condition Fimo, cut into small chunks and place them in the food processor. Process into tiny bits and then transfer the bits to your work surface. Compress the bits into a slab and roll smooth with an acrylic rod. Finish by rolling and folding through the pasta machine. MixQuick, or a few drops of Kato Clear Medium or Sculpey Diluent, will help soften stiff clay.

MEASURING TOOLS

The Marxit is a six-sided ruler that I designed for use with polymer clay. Constructed of a material that will not react with polymer clay, it features evenly spaced ridges in six different increments. To use the Marxit, simply press a side lightly to a cane or sheet of clay to transfer the marks. By cutting on the transferred impressions, you can make slices or strips of equal size. To produce graduated beads, mark a log of clay, then cut each progressively larger bead one marked section larger. Though the process is more time consuming, you can use a traditional ruler in an equivalent manner by scoring a line at appropriate increments.

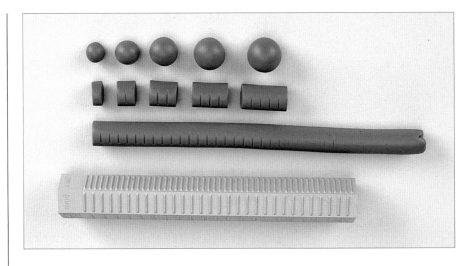

The Marxit tool simplifies measuring and marking increments of clay on logs or sheets, which can then be cut to size and formed into snakes, balls, beads, or strips of equal or particular size.

CUTTING TOOLS

Sharp blades are a must for polymer clay users in order to produce clean cuts that do not distort the shape of the sliced object. Originally, our choices were microtome tissue slicers and wallpaper scraper blades. The Nublade (introduced by Prairie Craft Company) was the first blade designed for polymer clay artists. It is 6 inches long and slightly thicker than the tissue slicer (though just as sharp). The stiffness minimizes torque as the blade cuts through thick slabs of clay. The Nuflex blade is also 6 inches long. Made of stainless steel, it is perfect for making curved cuts. The T Blade is also stainless steel and 4 inches long. Since the introduction of the Nublade, many other companies have begun selling blades specifically designed for polymer clay use. For detail cutting, X-Acto knives work very well.

PIERCING TOOLS

Kemper Enterprises of Chino, CA, manufactures my favorite needle tool, the Pro Tool. This inexpensive precision tool features a thin aluminum handle with a moderately sharp point protruding straight out from the handle. The straight alignment greatly simplifies the process of drilling straight through a bead hole rather than having to "fish" for the right spot on the other side.

There are many other needle tools available. You may also make your own needle tool: Form a handle out of polymer clay, insert the eye of a carpet needle, then bake the entire piece. Other alternatives include bamboo skewers and thin knitting needles.

ROLLING TOOLS

Rollers and brayers are devices used to smooth the clay or to form it into sheets. There are several types on the market today. Manufactured for use in the photographic industry, Lucite rollers are the most expensive but are the best type for polymer clay as the clay does not build up or stick to the Lucite surface. Cleanup is simple: Just rub the brayer with an alcohol-soaked paper towel. Wooden rollers may also be used effectively but some care must

be taken; since the clay tends to build up on the wood, the roller must be frequently cleaned. Maintain light pressure when rolling—smashing the roller into the clay will create a mess. To smooth larger areas of clay, or to make larger sheets, an acrylic rod is most useful.

The best and simplest way to form sheets is with a pasta machine. It works equally well with all brands of clay and can produce uniform sheets as thin as paper by rolling prepared clay through progressively thinner settings. Once you've used a pasta machine for polymer clay, it must never be used for food preparation. Every so often you should clean your pasta machine; to do this, press a saturated paper towel on the rollers as you crank. Clean the plates below the rollers. The machine can be taken apart—but only by someone with some experience doing so. If the bottom plates are exposed, clay may be dislodged with a bamboo skewer or plastic implement—never use a metal tool, as it may damage the edge of the plates.

Very sharp blades are essential for producing clean cuts, with no distortion of the sliced object. But remember, tissue slicers are extremely sharp, so always look at the blade before you reach for it.

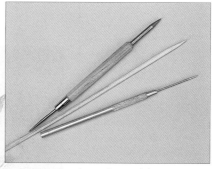

A variety of tools can be used for piercing a hole through a bead. The Pro Tool (bottom) produces a moderate-sized hole; for larger holes, pierce beads with a thicker needle tool or a bamboo skewer. The Pro Tool's point is also useful for picking up tiny bits of clay to apply to larger pieces.

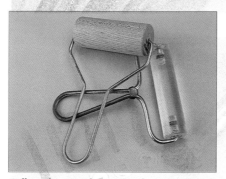

Rolling clay into sheets is easily accomplished with wooden or Lucite brayers. The brayers are also useful for smoothing edges on a piece in progress, such as when refining the curves of a layered cuff bracelet.

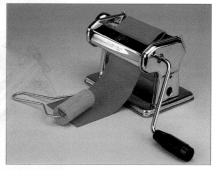

The pasta machine is a wonderful time-saving device. Not only will it easily produce sheets of any thickness, it also serves to blend colors for certain effects. Pasta machines have dropped in price considerably in the past few years, or you may be able to find one at a yard sale.

MODELING TOOLS

Polymer clay can be modeled and tooled prior to curing or afterward. The Pro Tool or dental tools come in handy for scoring and impressing your work before curing. Micro carving tools can be used on cured clay.

Colour and Clay Shapers, made in England by Forsline & Starr, are rubber tipped tools originally designed for use by painters and ceramicists. Available in "soft" (ivory tip) and "firm" (gray tip), they come in 5 shapes (taper point, cup round, cup chisel, flat chisel, and angle chisel) and four sizes (2, 6, 10, and 16, from smallest to largest). Realizing their potential in the polymer market, they produced a line called Clay Shapers (black tip), which are stiffer than the firm Colour Shapers. I find Colour and Clay Shapers unsurpassed in their superior blending, smoothing, and textural capabilities.

TEXTURIZING, SHAPING, AND EXTRUDING TOOLS

Look around and you will find that almost anything that features some texture can be used to detail your clay. Screw heads, chains, washers,

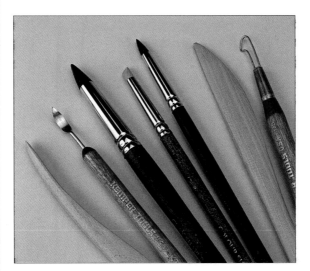

Many of the conventional sculpture tools found in art supply stores adapt very well to use with polymer clay. Forsline & Starr's Colour and Clay Shapers are new to the market but well worth the effort to locate.

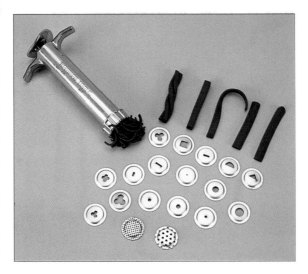

The Klay Gun from Kemper comes with nineteen interchangeable discs that make for easy extrusion of hair, grass, rope, tiny clover leaves, architectural detailing, and other variations that can be used in many ways.

screens, rubber stamps, and dog toys. Ball stylus tools can be used to create "stippled" effects and for sculptural detailing. The perfectly round ball leaves a small round impression without gouging the clay.

They're all around you! Take a stroll through the kitchen gadget department or through a hardware store for more texturizing ideas. As with all other tools, dedicate these to your clay and don't use them in food preparation. Once you begin, you'll find yourself continually seeking out textures and patterns that can embellish your clay.

Clay Extruding Tools

Kemper Enterprises' Klay Gun was originally designed for use with ceramic clay. Luckily, its use has successfully transferred to polymer clay. Resembling a small cookie press, this wonderful tool has a chamber, a plunger, and a screw-on cap that holds one of its nineteen discs in place. Simply load the gun halfway with conditioned clay, screw a disc in place, and push the plunger. Out comes an array of shapes, which can be put to many different decorative uses.

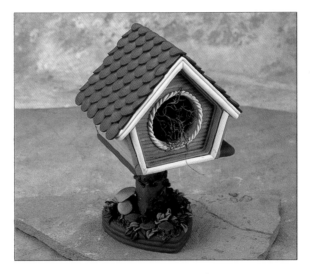

The siding, rope edging, trim, and base edging of the birdhouse were all formed with the Kemper Klay Gun, as were the intricate thatching on the large picture frame and the twisted border of the heart-shaped frame. The delicate veining on the leaves of the pinkish frame was accomplished by gently impressing the formed leaves with the side of a fine needle tool, and the whole frame was whitewashed after curing.

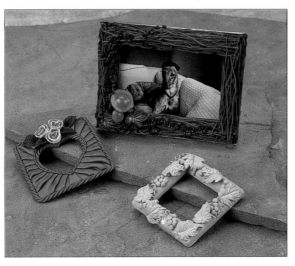

The softer the clay, the easier it will be to extrude from the Klay Gun, although with the addition of sufficient softeners, even the stiffest clay will work. The gun does not have to be cleaned after each use; simply slide the plunger through the chamber, scraping off the excess, until the plunger slides smoothly and does not stick. For thorough cleaning, saturate cotton balls or a paper towel with alcohol and press through the chamber.

Rubber Stamps

Rubber stamps (deep and shallow cut) can be used with raw clay to impart texture. A release agent, such as water, must be used to prevent clay from sticking in the stamp. Spray the stamp with water, press the clay into the stamp, then lift and dry the clay.

SHAPED CUTTERS

Shaped cutters can be a real time saver as well as ensuring consistent results. Kemper Enterprises offers heart, circle, teardrop, posie, square, triangle, and rectangle shaped cutters in sizes ranging from $3/16$ to $3/4$ of an inch. They also sell rose and leaf cutter sets.

Amaco markets open-backed stainless steel cutters in a wide range of shapes in small sizes. Wilton's inexpensive plastic "bite size" cutters are available in many shapes at most craft stores. The cutters I find most useful are the simple circle and oval cutters found at most cooking stores.

MOLDING TOOLS

Amaco was the first company that produced molds for use with polymer clay. Their initial cast resin molds were finely detailed and crisp. Since then they, and others, have begun producing softer more flexible molds that, I have found, do not create reproductions of the same clarity.

Consider making your own molds of polymer clay. Find an item you'd like to reproduce. Ideally, the item should have no undercuts that will trap clay and produce an inferior reproduction. To keep the clay from sticking to the item, spray the item and the clay with water (you may also dust with cornstarch or spray with Armor All). Press clay onto the original. Remove the original and bake the mold following manufacturer's instructions. To use

Kemper cutters (top left) feature a plunger that releases trapped clay. Standard cookie cutters are easily located and come in a very wide range of shapes and sizes, including "theme" designs such as bears, gingerbread people, holiday motifs, and many more.

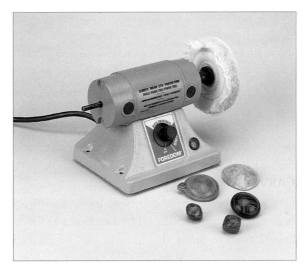

If you plan on producing a large volume of pieces that will require buffing, you may want to consider purchasing equipment to save time. Though hand buffing also produces excellent results, a tool such the Foredom Bench Lathe, fitted with a muslin wheel, will greatly speed the process.

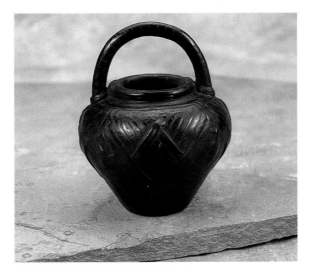

For an interesting look that closely resembles traditional clay, a plaster vase was covered with Promat and Sculpey III, and after curing was sanded and treated with Future Floor Wax for a thin, matte finish.

the mold, treat it with a release agent, press raw clay into it, remove the clay, then bake the reproduction. For more about moldmaking, see Chapter 4.

GLAZING AND POLISHING TOOLS

Cured clay may have a matte, satin, or shiny finish, depending on the brand. There are surface glazes such as Fimo Glaze or Sculpey Glaze that may be brushed on the surface to impart shine. Sculpey Glaze yellows over time, while Fimo Glaze is less likely to do so. Future Floor Wax is another option. As a general rule, water-based products work best and they will not create a chemical reaction that will result in stickiness.

Surface imperfections will be magnified by glazing, so for best results the piece should be sanded smooth beforehand. Surface glazing may result in a "gloppy" look so you may prefer to achieve your surface sheen by sanding, then polishing on an electric buffer. To contain polymer dust, sanding should be done under running water with wet/dry (automotive) sandpaper

(400 first, then 600 grit), available at hardware and home improvement stores. Ordinary sandpaper will disintegrate if used with water. (For instructions on the sanding process, see page 72.)

After sanding is completed, the piece can be buffed. I use a variable-speed Foredom Bench Lathe fitted with an unstitched muslin wheel. If you feel a buffer isn't worth the expense, you can achieve almost the same effect by sanding as instructed, then rubbing the piece against worn denim or polar fleece. (See page 73 for more buffing instructions.)

CARVING TOOLS

Cured polymer clay, though quite hard, is easily carved with good tools. The best are those manufactured by Dockyard Model Company. Ranging in size from 1.5mm to 5mm, they may be purchased individually or in sets. The U-gouge and V-gouge tools are the ones I most frequently use. They form cuts that in cross section look like those letters.

Linoleum cutters work well and are more readily available, generally from any art supply or craft store. The best-known manufacturer of these inexpensive tools is the Speedball Company. Their blades tend to be wider and the "V" less sharp than Dockyard V-cutters. A combination of tools from both companies is optimum—Dockyard's Micro Fine and the larger gauges from Speedball for when deeper cuts are necessary, as in Bakelite imitations.

DRILLING TOOLS

While it is easier to create holes in the clay before curing, cured pieces may be drilled as well. Kemper makes an extremely fine hand drill as well as drills in larger sizes. Simple drill bits alone work very well, too. If you choose the hand drill method—which is effective but time consuming— begin with the small drill then move up to the larger ones. Dremel makes an electric drill and drill press that production bead makers frequently us. Just pull down on the lever to drill a hole in a bead.

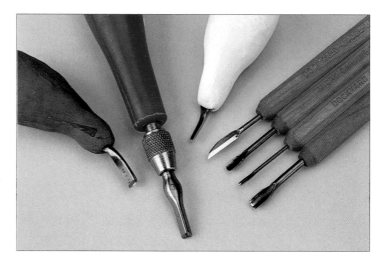

Dockyard's carving tools—often used for shipmodeling, decoy carving, and furniture restoration—feature individually forged blades of resharpenable steel, set in octagonal cherry handles for a comfortable and secure grip. Linoleum cutters, also good clay-carving tools, offer interchangeable blades that are screwed into a common handle, such as the red one seen here. Rather than constantly changing the blades you may opt to purchase several handles. Or form a handle of polymer clay, insert a blade, and bake the whole assembly for a permanent handle.

BAKING EQUIPMENT

Polymer clays cure at low temperatures and manufacturers recommend they be cured in an ordinary home oven, a toaster oven, or a convection oven. All ovens should be calibrated—make sure the temperature settings are accurate with an oven thermometer. Temperature is critical when curing polymer clay; you want to avoid burning but you need adequately high temperatures for proper curing. Invest in a reliable timer so that you can monitor the curing time of a batch or project. WARNING: Polymer clay should never be microwaved. Please read "Baking Polymer Clay Safely" on page 41 for more safety information.

Toaster ovens are the riskiest way to cure clay—the temperature spikes and the heating elements are too close to the items being cured. For that reason, I now consider most ordinary toaster ovens a "last resort" option. The convection oven is the best oven for polymer clay use. I have two ovens that are turned on and off with the integrated timer so I've never burned anything. The temperature remains constant and accurate. Ideally, you'll have a dedicated convection oven for your clay use. If you don't have a dedicated oven, use your home oven. See "Basic Safety Guidelines" on page 40 for more information.

Nesting round items in loose batting or placing flat items on quilt batting or a piece of paper towel will prevent items from forming the flat shiny spots that shape when clay is cured on a slick surface. Don't use waxed paper—it will melt. Dimensional beads with all-over detailing may be baked on skewers or nested in loose batting. If you use skewers, lay them across the edges of a pan or stand them upright in a heatproof cup. (See page 60 for more about curing dimensional beads.) As with all other equipment, cookie sheets, skewers, and any other supplies you use for baking your clay must not be used for food.

MISCELLANEOUS SUPPLIES

A number of art supplies and craft materials can be adapted to polymer clay use. Experiment with the ones listed below to obtain a variety of effects.

Metal Leaf

Metal leaf has been used as an art material for hundreds of years, to adorn everything from picture frames to the lavish interiors of the aristocracy. While karat gold and genuine silver may be used, most polymer artists use the less expensive composition leaf. It is sold in art and craft stores in gold, silver, copper, and many variegated and patterned versions. Thinner than paper and packaged between sheets of tissue, it should not be confused with metallic foils that are backed with cellophane.

Metal leaf may be applied to the clay either before or after baking. Although the leaf readily sticks to raw clay, once cured, it does not permanently adhere to clay. Therefore, it must be sealed after curing. An

application of Kato Clear Medium or Liquid Sculpey, and a return to the oven to cure will seal the leaf and prevent chipping. To add leaf to cured pieces, use a bonding agent such as Liquid Laminate by Beacon Chemical, or Special Bonding Agent by Magic Leaf. Seal the leaf with an acrylic brush-on or a layer of Liquid Laminate. This will protect the leaf and will also help retard tarnishing.

Paints

Cured polymer clay will accept water-based and certain oil paints without additional surface preparation. For antiquing, the best results are achieved by applying good-quality acrylics (such as Liquitex or Winsor & Newton) in thin washes rather than thick layers. Some oil paints can be used directly on clay, but oils should always be tested before committing them to a finished piece—some will actually dissolve the clay. I have successfully used Winsor & Newton oils in some of my imitative pieces. Artist Leslie Blackford uses oil paints (Winsor & Newton) to antique her pieces and I believe this is the best and simplest method—oil paint permeates the clay while acrylics lay on its surface.

For fine details, you can use water-based permanent markers. Archival-quality Pigma Micron pens are available in many colors and a wide range of tip diameters. Artist Jill McLean recommends the use of Rapidograph pens and inks, which do not fade or run.

Glitters, Mica Powders, and Specialty Paint

Glitter, glitter everywhere! Most any color may be found and used with your clay. Mix it in or apply it to the surface. It's messy, though, and contaminates clay easily, so try to work somewhere away from your raw clay. Extremely finely ground mica-based powders such as Pearlex (Jacquard), Fimo Pulvers, and Perfect Pearls (Ranger) can be used to impart metallic sheen to raw clay. Fimo Pulvers are toxic and must be used with care. Perfect Pearls are resin-coated and adhere best to clay and do not need to be sealed, unlike the others.

To make raised patterns or dots, you can use thick squeeze-bottle fabric paint. These paints take a long time to dry and remain rubbery after drying.

Embossing Powders

Manufactured for the stamping industry, embossing powders come in a tremendous variety of colors and color mixes and lend themselves to extensive experimentation. When creating imitative effects, I use the mixed colors with minimal metallic particles. In addition to mixing the powder into the clay, you can produce interesting effects by coating an uncured item with powder. Let the item cool completely before handling. (For more about embossing powders, see page 95.)

Eyeshadow and Blush

Powdered eyeshadow and blush are an inexpensive alternative to costly metal powders. Just brush the powder onto your uncured piece and bake. If you need finer detailing, wet the powder and use it like paint. Once these items are used on clay, do not use them on your face.

Glues and Adhesives

Several glues work quite effectively with polymer clay. Bond Victory 1991 provides an extremely strong clay-to-clay bond. Gel and liquid-type super glues work extremely well in gluing clay to metal and clay to Buna (rubber) cord. Adhering cured clay to glass requires the use of a silicone-based glue such as E-6000 or Goop. Kato Clear Medium or other liquid polymer clays can be used for a strong clay-to-clay bond, either raw clay to raw, or cured to raw.

Armature Supplies

Materials such as heavy-gauge wire, aluminum foil, and masking tape provide support and bulking for sculpture. Styrofoam is not a suitable armature material, as it will not withstand the baking process and will result in cracked clay. For more information on armatures, see Chapter 8.

Available in many colors, the squeeze bottle dimensional craft paints manufactured for fabric will work well on cured clay. The bottle's pointy tip simplifies application and allows for fine detailing.

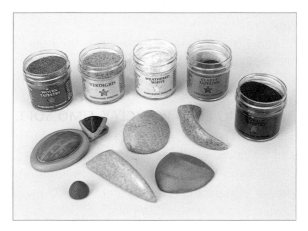

The embossing powders from Personal Stamp Exchange produce wonderful imitative stone effects when mixed directly into the clay. Their verdigris and translucent powders make green granitelike effects; cobalt tapestry and translucent combine for lapis lazuli; and weathered white and black produce black granite.

Conditioning the Clay

Regardless of brand or intended use, polymer clay must be conditioned prior to use. If you try to make something with unconditioned clay, the finished piece will be weak and brittle. The process of conditioning simultaneously ensures maximum durability and piece-to-piece adherence. During manufacture, polymer clay's basic ingredients—both wet and dry—are completely mixed and are then in their softest state. If you could use them at this point, conditioning would be unnecessary. Over time, as it ages (advances), the clay becomes stiffer as the dry ingredients absorb the wet. By the time you open a package, the ingredients have relaxed into a new formation; they have, in a sense, regrouped from their initial mixed state. By conditioning, you are releasing the wet ingredients from the dry and returning the clay to its original state.

Depending on initial consistency, polymer clay is conditioned by hand kneading, processing it in a food processor, and/or running it through a pasta machine. As the softest, Premo and the Sculpey branded clays are the easiest to condition, while Fimo, the stiffest, is the most difficult. However, ease of conditioning should not be the criteria in clay selection as the softer clays may, in fact, be the most difficult to handle. Kato Polyclay, Fimo Soft, and Cernit lie somewhere between these two extremes and are comparable in terms of the amount of work that must be expended during their conditioning.

PREPARING THE SCULPEY CLAYS—SCULPEY/POLYFORM, SCULPEY III, SUPER SCULPEY

Begin hand kneading by squeezing the clay in your hand, continue squeezing until it resembles a thick sausage in shape, then roll it between your palms to elongate the clay. Fold it in half, twist the ends in opposite directions, forming a thick rope. Roll the rope between your palms again, fold, and twist. Repeat until the clay can be stretched without immediately breaking. It is possible to overcondition it to the point of extreme softness. If this happens, let the clay cool (you can just let it rest for a while or place it in your refrigerator).

If you have a pasta machine, cut a slice from the block and roll it through the thickest setting. Continue folding and rolling until the clay is pliable and has a bit of stretch without immediately breaking.

PREPARING KATO POLYCLAY, FIMO SOFT, AND CERNIT

Kato Polyclay, Fimo Soft, and Cernit respond to pressure rather than heat and are easily conditioned in that way. Cut a slice approximately 1/2 inch thick. With an acrylic rod, flatten and compress until the slice is just a bit thicker than the thickest setting of the pasta machine. Roll the slice through. Reset the pasta machine, skipping one setting—i.e., on an Atlas machine

you've gone from setting 1 (thickest) to setting 3. Without folding, roll the sheet through. Fold the sheet and roll through. Repeat until the clay is soft and pliable and does not crack when folded.

These clays may also be conditioned by hand. Cut a thick slice and flatten very thin with an acrylic rod. Fold the sheet in half, then fold it again. Roll it thin again with the rod. Continue, folding and flattening until the clay is soft and pliable.

PREPARING FIMO

Fimo products are imported and, therefore, subject to greater advancing and change from the factory to the consumer. Fimo users have devised different strategies for overcoming the clay's initial stiffness and handling difficulties and expediting the conditioning process. Begin by warming the still-wrapped package of clay slightly, either by sitting on it, by placing it in your pocket, by floating it (in a sealed plastic bag) in warm water, by placing it under a

"Pegasus," inspired by a traveling show of works by the artist Botero, is an 8-inch tall sculpture created of tan Sculpey III that was applied to a foil armature, cured, and then given a thin wash of white acrylic paint.

warming pad set on low, or by heating it in a clay warmer. Once the clay is warm, unwrap it and cut it into small chunks. Drop the chunks in a food processor, add a few drops of Kato Clear Medium, Sculpey Diluent, or a few small chunks of MixQuick and pulse the processor until the clay has been chopped into small bits. Continuous processing may heat the clay to curing. Scoop the clay out and shape the bits into a thick slab. Roll flat with the acrylic rod. Turn over and roll smooth. Continue rolling until the slab is just a bit thicker than the thickest setting of the pasta machine and the bits are sticking together. Roll through the pasta machine. Fold the sheet in half and roll through. Continue folding and rolling until the sheet is smooth and free of air pockets.

Hand methods may be employed as well, but you'll probably need to condition the clay in quarter-package increments.

Polymer Clay and Color

As is true in most of the visual arts, color selection is of paramount importance for the polymer clay artist. The best millefiori artists, for example, are expert colorists—it takes time and practice to discover which color combinations work best for which applications. Packaged colors, available in an extremely wide array, can be used as is, or they can be altered to achieve any color you desire. A basic knowledge of color mixing principles will prove helpful as you experiment with the medium.

COLOR BASICS

The strength, or intensity, of a color can be altered by adding white, black, or another color. With Sculpey III, Promat, Fimo, and opaque Cernit, the addition of white not only alters intensity but increases the color's opacity. For a wonderful dimensional effect, try creating shaded bull's-eye canes, which can then be adapted to a variety of shapes and uses (see the leaf cane on page 51, for example). Begin with a white or light-colored core, then wrap it with progressively richer shades of a chosen color, achieved by adding greater and greater amounts of color to the white or other core color for each successive sheet.

The addition of translucent clay does not significantly alter the color of a clay but does increase the translucence. Awareness of colors' translucence or opacity is particularly important when constructing millefiori canes. A translucent white, for example, placed next to black or another very dark color will be indistinct in the finished cane because you will actually be seeing the darker color through the light one. Translucent color can be used successfully in millefiori canes when colors are selected with care, such as in the chevron and the Clichy rose canes (pages 50 and 54), where translucent clay increases the illusion of depth and therefore imitates glass quite effectively. Also bear in mind that the quality of the image must be maintained through the process of reducing a millefiori cane, and that an image distinct in its original size may completely disappear once reduced. You'll find that light opaque colors remain more distinct than muddy darker tones. Of course, successful canes are usually constructed of both types.

Value—the darkness or lightness of a color—is the most important consideration when selecting color for millefiori because it largely controls contrast. The greatest contrast is achieved when complementary colors are placed side by side. By controlling the lightness or darkness of those colors, you can achieve maximum contrast. Remember too that warm colors (ranges of red, orange, and yellow) tend to advance in an image while cool colors (ranges of green, blue, and purple) recede.

COLOR MIXING

The key to achieving successful color mixes is to experiment and to be aware of what proportions of each color went into the successful blend. Beginning with the dominant color, add bits of other colors until the desired shade is reached. There is a simple trick to keep track of proportions. Roll out sheets of each color you want to blend (keep them all of the same thickness). Using a small cutter of any shape, cut several shapes from each color and begin blending. Once you reach the desired blended color, count the number of shapes of each color used. This will tell you the proportions of each clay used in the blend, which can then be applied on a larger scale to blend bigger batches. For future reference, keep a list of the proportions you used for successful blends.

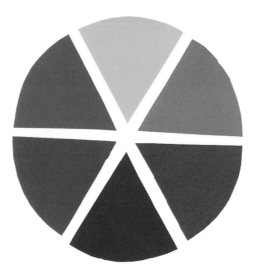

A polymer clay color wheel demonstrates the basic principles of color mixing. The three primary colors—red, yellow, and blue—cannot be obtained by mixing but in varied combinations create all other colors. Secondary colors are obtained by mixing two primaries: blue and red combine to make purple; red and yellow produce orange; and blue and yellow result in green.

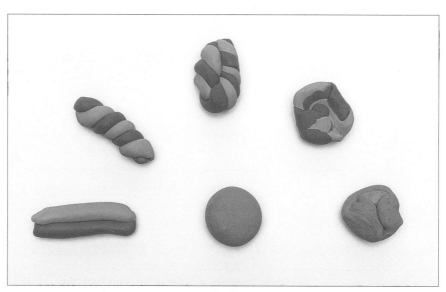

Experimentation with various proportions of different-colored polymer clay will yield an almost infinite range of shades and tones.

Making Basic Shapes

Now that your clay is ready, so are you. Although this book explains how to use various tools with polymer clay, the most basic and useful tools are still your own hands. Master these few simple shapes and you can make everything from fruit to nuts, and a lot more.

In their simplest forms, the basic shapes used to create the chimpanzee can be used to produce different types of beads, or they can be combined for simple figurines. A slightly ovoid ball forms a basic head shape. A larger oval becomes a torso. Elongate a cone and you've made simple arms and legs. Flattened teardrop shapes become hands and feet. In this way, you'll be able to fabricate simple figures like the chimpanzee, and, with practice, to adapt and expand upon these concepts to create more complex figures and other forms.

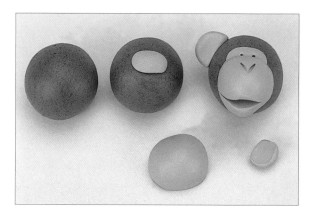
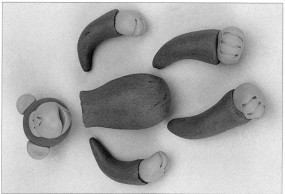
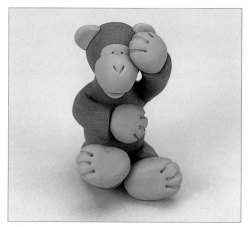
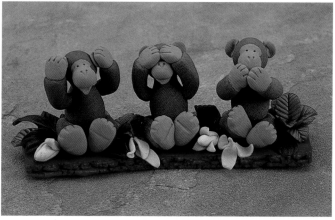

The chimpanzee's head is just ball of clay (in this case, Sculpey III) with a flat oval of tan smoothed on for the eye area. A half ball forms the muzzle, which was cut open with a tissue slicer and slightly opened for the mouth. Two flattened balls serve as ears. Eyes were made with a small ball stylus, and nostrils formed by angling the stylus to impress a "V" shape on the muzzle. The body began as an oval, from which a neck was pulled. Elongated cones form the arms and legs; hands and feet began as flat teardrop shapes, then fingers and toes were detailed with the ball stylus. The various pieces were attached to one another and smoothed together. The posed chimp was cured and joined two others in the classic ". . . No Evil" pose.

ROLLING AND PIERCING A BALL

Place a wad of clay between your palms and move your hands in a compact, circular motion, exerting light pressure on the clay. Open your hands and you should have an orb. If you wish to make a round bead, you'll need a needle tool, such as the Pro Tool. Hold the uncured ball in one hand and "drill" by rolling the tool back and forth through the bead until the tip pierces the opposite side. Using the same drilling motion, withdraw the tool. Now drill through from the opposite side, entering from the pierced spot where the tool exited before, then drill back out again.

Beads can also be drilled after curing. Many production bead makers (those who mass produce and sell their beads) have found this quicker than drilling before curing. Dremel's hand drill, if fitted into its drill-press-type mechanism, can be used with one hand as you steady the bead with the other. To simplify the process, polymer clay artist Irene Scherping recommends piercing a small hole in the bead prior to curing to provide an indent in which to place the tip of the drill.

Ball Variations

- *The Teardrop.* Place a ball on a flat surface. Place your hand against the ball at a 45° angle and roll.
- *The Cone.* Form a teardrop shape, then place the round part on a flat surface, with the point up. Press down gently, flattening the bottom of the teardrop.
- *The Bicone.* A bicone looks like two cones whose flat sides have been joined and smoothed. Beginning with a ball, reshape by rolling between your palms in tight circles, applying moderate pressure.
- *The Oval.* Roll a formed ball between your palms in wide circles, applying moderate pressure. When making small figurines, this shape is elongated to form arms and legs.
- *The Lozenge.* Begin with an oval, then flatten it with your fingers.
- *The Wafer.* Flatten a ball between your palms, then refine the edges with your fingers. The center area should be thicker than the edges.

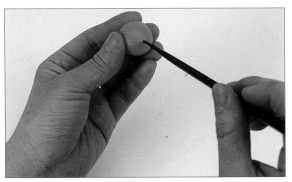 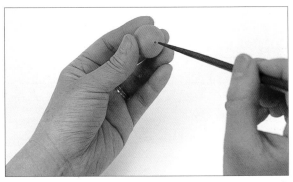

Regardless of bead shape, whenever holes are made prior to curing, the same kind of "drilling" procedure is performed with a needle tool. After drilling all the way through, turn the bead around and drill back the other way through the same hole.

Seen here, from left to right, are the ball, the teardrop, the cone, the bicone, the oval, the lozenge, and the wafer. All started as a simple ball rolled in the palm of the hand, and all will work as beads or as the beginnings of sculptural elements.

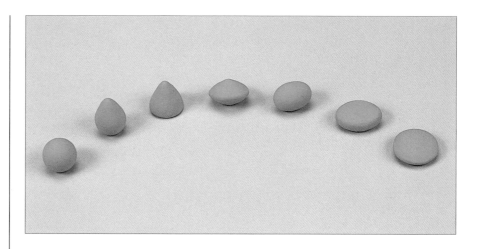

ROLLING AND CUTTING A LOG OR SNAKE

Terminology can be somewhat subjective. Some people call a thick roll of clay a "log" and a long skinny one a "snake"; others refer to snakes as "coils." I consider a log to be a thick, short, cylindrical shape, of no specific width or length. Snakes are longer than they are wide, and round in cross section.

As with many other shapes, logs begin with a ball; the larger the ball, the larger the resulting log. Roll the ball back and forth on your worksurface. Pick it up and flatten the rounded ends by pressing them on your worksurface or cutting them off with a blade. Alternate the rolling on its side and the flattening until you've formed a cylindrical shape with flat ends.

A good, even snake is a bit more difficult to produce. Beginning with a ball or a log, roll it on your worksurface, applying light pressure with your fingertips; don't push too hard or your snake will be lumpy. Or, for a more forgiving method, roll it between your palms, moving your hands in a circular motion; if you push too hard, you'll still form lumps, but fewer of them. If you notice irregularity in the thickness of the snake, just place your hands at the thick point and roll your hands over it until it evens out.

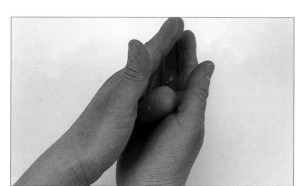
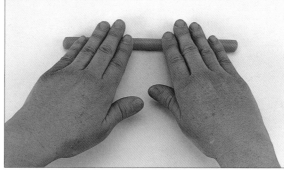

A good, uniformly sized snake is the result of the combined pressure and pulling action as your hands move over and away from the center. The pulling action is more critical to successful formation than is the pressure. I use almost no pressure as I roll, but my hands are constantly moving, coaxing and pulling the clay which moves out with them, consequently becoming thin and long.

Log and Snake Variations

- *The Tube.* Beginning with a log, use a drilling motion to put it on a skewer. Place the skewered log on your worksurface, then roll as you would a snake, moving hands outward. When you've achieved the desired diameter, loosen the tube from the skewer but do not remove it. Slice the thinned log into beads by cutting with a sharp blade as you roll the tube. Remove the cut pieces from the skewer and bake.

- *The Coil.* To make a spring-shaped bead, loosely wrap a snake (with either tapered or untapered ends) around a needle tool, skewer, or knitting needle. Gently loosen and remove from the implement.

- *The Doughnut.* Wrap a snake around a needle tool, skewer, or knitting needle. Using a tissue blade, cut from the top of the coil to the bottom. Loosen and remove from implement. Separate each piece. To make a small doughnut, bring together the cut ends of one piece and smooth the joint. Large doughnuts are made by bringing the ends of a thick snake together, then smoothing the joint.

- *Simple Loaf.* Beginning with a log, roll with your hands or a brayer to form a flat plane on top and bottom. Turn the log 90° so that one of the rounded sides sits on your worksurface. Roll again, forming the other two flat planes. Keep rolling and rotating until you have formed corners.

Beads needn't be round or even oval. Tube beads—which make wonderful spacers for your jewelry—start out as a log. Coil beads are wonderful twisty spirals that are easy to make. Doughnut-shaped beads begin in a way similar to the coil bead; the formation is then sliced and the circles separated and rejoined indivually.

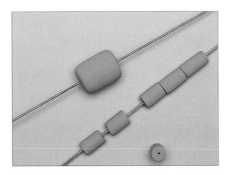

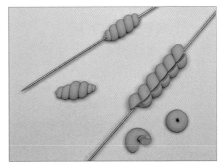

A simple loaf begins as a log that is rotated and slightly flattened. It can serve as the basis for several techniques, including beads and millefiori canes.

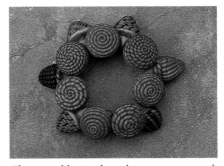

The striped button bracelet was constructed of gold Promat combined with green, brown, red, and black Sculpey III, all twisted into thin snakes and coiled and spiraled onto base beads. The cured buttons were strung on a piece of elastic with a spacer bead between each.

ROLLING A SLAB OR SHEET

In general terms, a sheet is uniformly thin and a slab is really just a thick sheet. Both are extremely useful forms, frequently found in sculptural pieces as well as in millefiori production for outlining and packing. Thin sheets of translucent "flesh"-colored clay are often used to form "skin" over sculpted doll faces. Slabs can be used to fabricate clay boxes and vessels, or preexisting vessels can be covered with thin sheets of clay.

There are two basic methods of forming sheets and slabs from conditioned clay: with a roller or brayer, or with a pasta machine. For the roller method, some people prefer rolling pins or Lucite rollers, but I find a single-handled brayer easier because it can be operated with one hand, leaving my other hand free to move the clay. Begin by rolling conditioned clay into a ball, then flatten the ball with your fingers until you have a fat pancake. Place the pancake on your worksurface and, holding one edge, roll from the center of the clay toward the other edge. Rotate the clay a quarter turn, reposition your hands, and again roll from the center toward the opposite edge. Repeat until the sheet is the desired thickness.

If you have a pasta machine dedicated to polymer clay use, you'll find that it produces sheets of absolutely uniform thickness. With your hands, form a conditioned mass of clay into a thick, roughly square slab, then feed it through the pasta machine on the thickest setting. Continue feeding the clay through on progressively thinner settings until the sheet reaches the desired thinness. Don't jump to a thin setting too quickly or the clay will ripple and tear.

Once you've formed your sheets and slabs, you'll find a multitude of uses for them. Many shapes can be made by cutting them from a slab or sheet with a blade, shaped cutter, or fine needle tool. To make flowers, for example, rather then forming each petal and leaf individually, it is much easier to cut the initial shapes from a sheet, then refine and detail them. Entire vessels can even be constructed from slabs of clay (see pages 116–19).

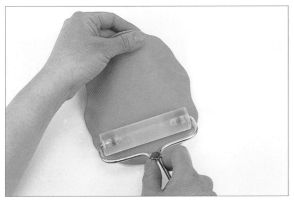

Though the pasta machine produces the thinnest and most even sheets, hand-rolling with a brayer will also yield good results. Keep rotating the clay and applying even pressure as you work.

Sheet- and slab-making is easily mastered and has many uses. Thin sheets can be used to cover forms (including canes and vessels), or shapes can be cut out of the sheets; thicker slabs can serve as vessel walls, among other applications.

Cabochon Techniques

Cabochons are rounded, vaguely triangular forms with a domed surface, highest in the middle and tapering toward the edges. They do not have holes for stringing or hanging, but their flat back is perfect for setting in a variety of surrounds. They can be used to create pins, earrings, pendants, and other decorative accents.

MAKING CABOCHONS

Roll a ball of polymer clay, place it on a piece of paper (an index card works nicely), and flatten it somewhat with your palm. Refine the shape with your fingertips; if your clay has a surface pattern, be sure to push and press the clay rather than stroking it, which might blur the pattern. Press the edges toward the paper. Once you've achieved the desired shape, lightly roll the rounded top with a brayer to smooth. Bake the cabochon right on the paper (the heat won't harm it). If you intend to set the cabochon in a clay surround, bake it half the necessary time, since it will be baked again once in the setting.

SETTING CABOCHONS

Promat's lustrous gold, silver, and copper clays are ideal for creating settings, or bezels, for your cabochons. The silver appears somewhat like pewter; to brighten it, add a small amount of white. The copper looks more like a rusty barn red rather than a metallic copper; to make it more convincing, mix together gold and copper Promat.

Condition the chosen color, then roll it into a sheet of approximately 1/16-inch thickness. (The actual thickness of the sheet depends on the desired thickness of the bezel.) Place the cabochon on the sheet flat side down and cut around it. Holding the cabochon with the clay cutout beneath it, gently pull up the cutout so it rolls up slightly along the sides of the cabochon, forming a bezel. Press the whole piece on the rolled sheet again. You are now ready to add details to create a finished piece.

FINISH DETAILS

These details will be placed on the sheet, around the cabochon. Use them in any order or frequency in your piece. A clay gun fitted with a "hair" screen (or a garlic press, if you don't have a clay gun) can be used to make beaded, round, coin, or small rope edging. For large rope edging, use the clay gun with either the three-lobed or the four-lobed disc. After you've placed the desired details around the cabochon on the clay sheet, cut the sheet around the outermost detail and smooth the cut edges.

- *Beaded Edging.* Extrude a very short length and cut it off with a blade. Separate the cut bits, roll each into a tiny ball, and place the balls side by side around the cabochon.

- *Cupped Beaded Edging.* Create a beaded edge, then press a ball stylus into each of the balls.
- *Round Edging.* Extrude a length a bit longer than the cabochon's circumference, then wrap it around the cabochon.
- *Coin Edging.* Begin with round edging, then use a needle tool to make a series of closely spaced, parallel impressions along the top, perpendicular to the cabochon itself.
- *Small Rope Edging.* Extrude two or three strands and place them side by side on the worksurface. Twist the ends in opposite directions. For an extremely fine rope edging, begin with a round edging, then make a series of closely spaced impressions. Rather than making them parallel to each other as in coin edging, these should be formed at a sharp angle.
- *Large Rope Edging.* Extrude a long three- or four-lobed length. Twist the ends in opposite directions.

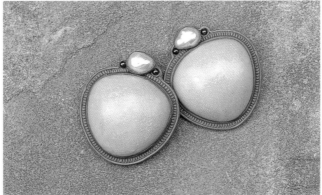

The luscious curve of the cabochon makes it perfect for earrings, brooches, and pendents. Create a lustrous gold or silver setting, then detail it with round, beaded, coin, or rope edging, or any combination thereof. Incorporate freshwater pearls or small semiprecious stones for an even richer look.

Basic Safety Guidelines

Polymer clay is classified as nontoxic. This does not mean that it can be ingested, but that it poses no hazard while working with it. If you plan to handle the clay on a daily basis, you might consider using latex gloves while conditioning the clay, then removing them to mold and shape it.

All brands sold in the American market carry the AP Nontoxic label, meaning they have been certified by the Art & Craft Materials Institute in testing conducted through Duke University. Even more importantly, they also bear the ASTM-D436 designation, indicating they meet the standard developed by artists, manufacturers, and toxicoligists in conjunction with the American Society for Testing Materials. In other words, polymer clay is classed as a product that has been established as having no chronic health hazards and is safe for all age groups.

Since cured polymer clay does not have the surface hardness of glass and will flake when its surface is scratched, food bearing vessels, plates, and utensils that have been covered or decorated with polymer clay should never be used for food or beverages of any kind.

Wearables to which any polymer clay items—such as buttons—have been attached can be washed by hand (Sculpey III) or in the washing machine (Kato Polyclay, Fimo, Fimo Soft, Cernit, and Premo). It is best to turn items inside out and air dry, rather than dry in the machine. Never dry clean polymer clay—dry cleaning fluid will melt the clay.

FUMES

Fumes are not emitted with ordinary baking and should not be confused with the regular odor of the clay. But, although uncured polymer clay is nontoxic and ordinary baking in safe, poisonous fumes are emitted if the clay actually burns. Each clay carries its own safe curing temperatures. If Premo, Fimo, Fimo Soft, and Cernit are exposed to temperatures above 300 degrees, they will most likely burn. Kato Polyclay is the exception as it may be cured up to 325 degrees safely. At 325 degrees, the baking time should be reduced by half.

If you use the clay to decorate candlesticks or votive candleholders, be sure the clay will be at least $1^{1/4}$ inch away from the flame; in other words, votives should have a minimum diameter opening of $2^{1/2}$ inches.

STORING POLYMER CLAY

From the time of manufacture until it is cured, polymer clay continues to "advance," becoming stiffer. Properly stored, your clay should last for years. Remember, if it's hard as a rock on the shelf, it won't get softer with time.

Polymer clay is not affected by cold, dry conditions. When not in use, it should be wrapped in plastic wrap or in plastic boxes bearing the

"5" recycle number and placed in a cool, dry place—away from direct sunlight. Do not store your clay in waxed paper as the wax draws the plasticizer out of the clay, making it dry and crumbly.

Exposure to direct sunlight may begin the curing process. Most clays begin curing at approximately 90 degrees (Kato Polyclay begins to cure at approximately 115 degrees) and exposure to those temperatures will affect the clay's workability. Polymer clays are not UV safe—prolonged exposure to sunlight will fade the colors.

BAKING POLYMER CLAY SAFELY

Since the thermostats of most ovens may not be reliable, it's best to test and verify your oven's temperature with an oven thermometer. It's also highly recommended that you invest in a good timer to ensure that you do not exceed baking times. Follow the manufacturer's instructions as to temperature and time of curing to ensure that the PVC particles fuse completely. Note that recommended baking temperatures may not be the same even within the same brand, Translucent clays tend to brown at generally recommended temperatures, and so are baked at a reduced temperature. Cernit clays cure between 215 and 265 degrees. Sculpey clays cure at 275 degrees. Fimo clays cure at 265 degrees and Kato Polyclay reaches particle fusion between 275 and 325 degrees. If you've mixed clays, it is safe to bake at the higher temperature for the recommended time. If any adverse affect is seen, it will be in color change. White will brown, translucent will yellow, colors will darken. Doll artists, in particular, cure pieces many times. With each subsequent curing, the colors darken until the head (baked first) and the feet (baked last) are completely different shades of "flesh." Tenting with foil over a baked part will help reduce this unwanted color change. The exception to the color change rule is Kato Polyclay, which does not change color with repeated baking.

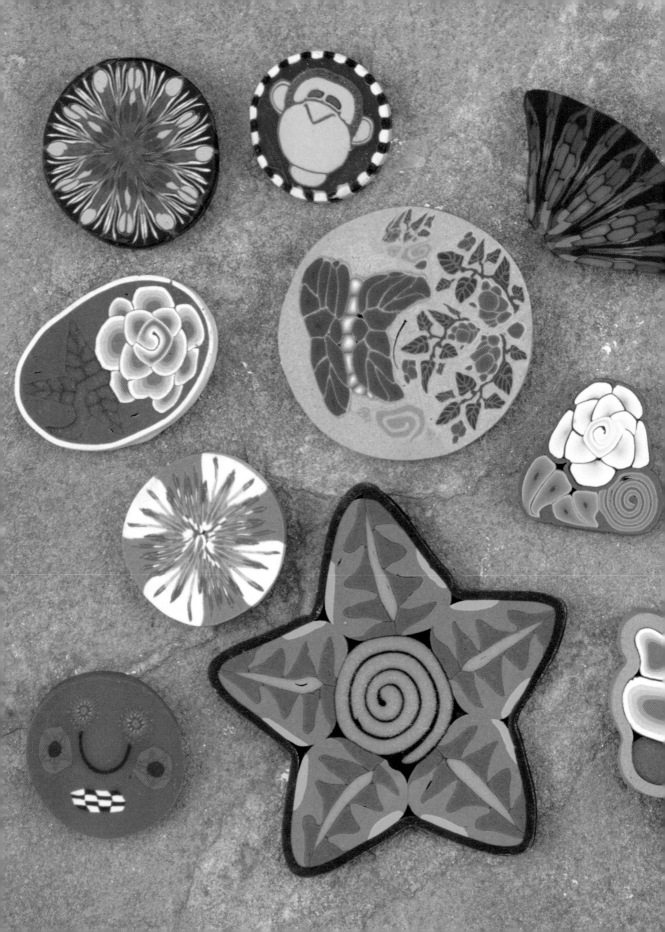

2 | Millefiori: Making Canes and Loaves

(Opposite) Cane patterns can be simple or complex, realistic or abstract. Though circular canes are most common, many other shapes are possible. (Above) When shaved very thin, abstract canes produce an intricate, fluid look.

The word *cane* refers to an ancient glassmaking technique in which rods of molten glass are combined and stretched to produce a long cylinder whose pattern, which is typically floral or geometric, is continuous throughout its length. In the Venetian glassmaking tradition these canes are cut into thin slices and applied to molten glass to make items such as beads and paperweights. These objects are aptly called *millefiori* (Italian for "thousand flowers"), as the tiny cane slices appear to form a carpet of flowers when placed side by side. The techniques employed by Venetian glass artists to make millefiori have been successfully adapted to polymer clay, and form the basis and inspiration for modern polymer clay canework.

Millefiori Fundamentals

Polymer clay is one of only a few materials that lends itself to traditional millefiori techniques. In adapting these techniques, polymer clay artists have also assumed some of its terms. For example, *cane* refers to any pattern or image, from the simplest to the most elaborate, that is assembled from elongated shapes of clay. A *complex cane* is composed of numerous simpler canes. A *loaf* is a block-shaped cane, often constructed from several sheets of different-colored or -toned clay. The process of compressing a cane's or loaf's elements by simultaneously lengthening them and decreasing their size is known as *reduction* or *miniaturization*. Like canes of glass, polymer clay canes can be reduced in size while maintaining the finest miniaturized detail within.

All brands of colored polymer clay can successfully be used to produce millefiori canes. Fimo, the hardest and the most opaque, is the best choice for making canes with a high degree of detail; its colors will remain distinct even after they are greatly reduced. The opacity of the clay insures visual separation of each color; you don't see one color through another. Cernit, however, because of its translucence, results in canes whereby adjacent colors "tint" each other and clarity is lost. To remedy this situation, Cernit introduced an opaque white (#29); adding ⅛ package of this white to each colored clay will create an opaque color that will produce a cane with adequate image clarity. Although the colors at first appear to lighten when mixed with the white, they will deepen upon curing.

By varying colors, cane styles, and bead shapes, millefiori techniques can yield a tremendous variety of effects.

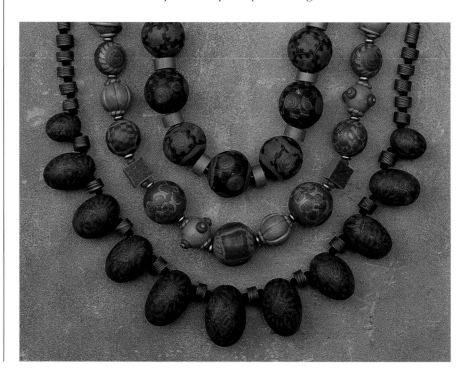

A clay's translucence is not necessarily a drawback when making canes. It can contribute a wonderful three-dimensional effect, resulting in canes that exhibit a depth not seen when using only opaque colors. When my translucent color is light, I generally use lighter opaque colors; dark tones tend to make the translucent shade appear muddy. Sculpey III offers both opaque and translucent colors. Yellow, orange, and red are translucent; if you desire an opaque effect, mix them with white ($^1/_{16}$ package of white to each package of color).

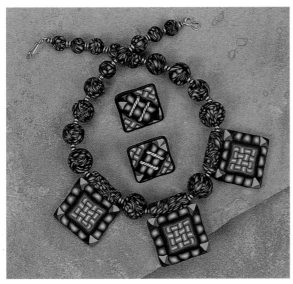

The large cane slices in the necklace and earrings feature shading produced by combining translucent Cernit with opaque white, a shading technique identified with the work of artists Steven Ford and David Forlano of Zen City Cane.

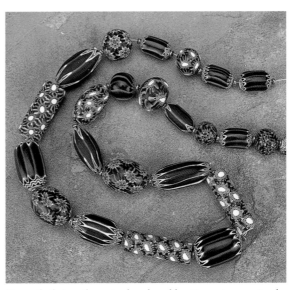

For a dark translucent color, deep blue Promat was mixed with translucent clay and caned with stark, opaque white, which lightens the blue shade and can be seen through the translucent areas.

A clay's translucence can be utilized to give canes a much greater depth than is possible when using only opaque colors. The blue opaque lace cane has a sold, dense, two-dimensional appearance, while the translucent-and-white lace cane exhibits depth and dimension.

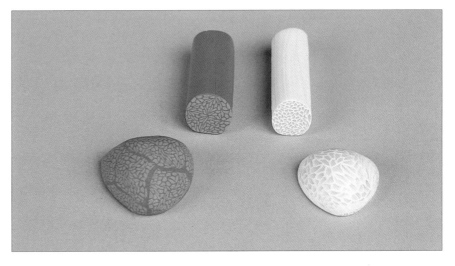

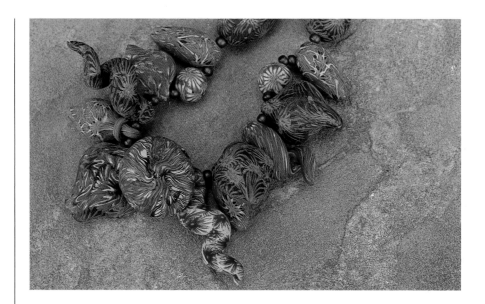

An arrangement of spirals and large hollow beads was covered with very thin slices of kaleidoscope canes, all made of Sculpey III. Because Sculpey III is somewhat soft, it may stick to the blade. To help alleviate this, place the reduced cane in the refrigerator for a while before slicing, and make sure the blade is absolutely clean.

There are several ways to alleviate the problems of softer, stickier clays such as Cernit and Sculpey III, which tend to squash and to stick to the blade when the cane is sliced. If you find the clay too soft, lay it on paper toweling and allow some of the plasticizer to leach out. Or allow the cane to rest for a day or so, or place it in the refrigerator for an hour or two. It also helps to wipe the cutting blade with rubbing alcohol to remove any oils or clay residue that contribute to clay sticking to the blade.

Promat works beautifully when making smaller canes but is not recommended for canes larger than 5 inches across. It is a heat-reactive clay containing no fillers and does not respond to pressure in the same way as Cernit and Fimo. Therefore, when reducing an extremely large cane, it becomes a problem to move the center while not overheating the outside. So for canes larger than 5 inches in diameter, use clays such as Fimo, Sculpey III, and Cernit. But the lustrous pearlescent colors in the Promat line will produce beautiful, luminous smaller canes.

Regardless of the brands you use, try to use clays with similar degrees of softness, which will go a long way toward reducing the distortion and waste that occurs during reduction. For example, if you make a cane combining equal parts of Fimo (the hardest), Sculpey III (the softest), and Cernit (somewhere in between), the Sculpey III will be the first to *move* (respond to the pressure of reduction), followed by the Cernit, then finally the Fimo. Consequently the reduced cane will be composed primarily of Fimo, some elements of Cernit, and just small remnants of Sculpey III. As discussed below, there are certain steps you can take to minimize loss of detail, including carefully preparing the cane prior to reducing it. Some waste at the end of your canes is unavoidable, but using clays of comparable softness will help decrease loss of detail as well as loss of clay. Although some millefiori artists insist that Fimo is the "only" clay to use, I have found that the most important factors are not the clay itself but the care and skill with which the clay is composed, packed, and, finally, reduced.

ASSEMBLING AND REDUCING A CANE OR LOAF

Two basic forms are used in assembling canes and loaves: snakes and sheets. Snakes are used anywhere a solid form is desired—for example, the circular center of a bull's-eye cane (see page 48)—or simply to fill spaces of any shape within a cane's design. Sheets can be stacked, used to outline other forms, or used to create a physical and visual "buffer" between two colors.

A sheet can also keep a form from distorting when a cane is reduced. For instance, if you're constructing a butterfly cane consisting of four teardrop-shaped bull's-eye canes for the wings, three round bull's-eyes for the body, and two jellyroll canes for the antennae, all set in a pink background, wrap the butterfly configuration with a sheet before packing the background. This step prevents the butterfly components from *spiking* or *scalloping* into the spaces between the colors. *Packing* is the act of filling in the air pockets between the various layers of clay. The more tightly you pack your cane, the less distortion you'll have after reduction.

The best way to reduce a cane is to stand it on end, then begin squeezing the sides, turning as you squeeze. The clay will start to elongate as it responds to the applied pressure. If you see that the perimeter of the cane is reducing faster than the center, press the area down with your fingers. Continue to squeeze and press as necessary. In the same way, if you discover the middle of the cane moving out while the perimeter is not, push down the center and try to draw the perimeter up. Turn the cane around to the other end and repeat. Once the cane is of a manageable diameter, it can be placed on your worksurface and rolled to finish the reduction. "Warm" canes—those that have recently been made—can be reduced with a combination of rolling and "pulling"; simply hold the cane in two places and slowly pull to elongate. With canes that have been resting for a while, you should work slowly, squeezing gently and pushing, warming up the clay gradually as you work.

When reducing loaves, begin as you did for a round cane, turning while squeezing the sides. Once the loaf is of manageable size, lay it on your worksurface and stroke one side, holding one end in place. Turn and stoke, turn and stroke, until you have the desired dimensions.

Air pockets are the primary reason for image distortion in millefiori canes. As a cane is reduced, the clay indiscriminately fills in these pockets. If the cane is packed correctly and the air pockets filled with snakes and/or wedges, distortion should be minimal.

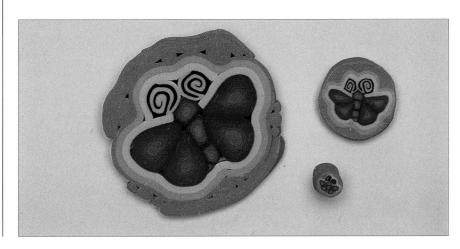

Basic Canes and Loaves

The following millefiori canes are considered the most basic and are frequently used in the making of more complex images. Although many polymer clay artists make huge, dinnerplate-sized canes for mass production of beads and other items, my canes tend to be of medium size, about 4 to 5 inches across and 2 inches long. I find this a manageable size, simple to reduce with minimal distortion. Beginners should always practice by making smaller canes. As you become more experienced and comfortable with the technique, you might opt to enlarge your canes.

BULL'S-EYE CANE

The bull's-eye cane is the simplest and one of the most useful of all canes. Just wrap a log or snake with a sheet of another color. Cut the sheet to fit around the core exactly, so that the ends of the sheet meet in a *butt joint*, forming a clean, clear outline of color around the core. Smooth the edges so the joint disappears. Although the bull's-eye starts out round, it can be manipulated into any shape. Several bull's-eye canes can be combined to make butterflies, leaves, letters, and many other forms.

LACE CANE

A lace cane begins as a single bull's-eye cane. Reduce it and then cut into six equal pieces. Arrange five of the pieces around the sixth, then reduce the reassembled cane and roll it smooth. Cut the reduced cane into four equal pieces, stack them two by two, and roll to smooth again. Stop here if you wish or continue the process to further refine the pattern.

Though basic, the bull's-eye cane lends itself to many adaptions and serves as the foundation of a number of more complex canes. Although the bull's-eye cane starts out round, it can be manipulated, reshaped, and used to make jellyrolls, outlined triangles or rectangles, and many other forms.

The intricacy of the lace cane begins with the simplicity of a single bull's-eye cane, which is reduced, cut, reassembled, and rolled smooth. The process is then repeated until the pattern reaches the desired degree of refinement.

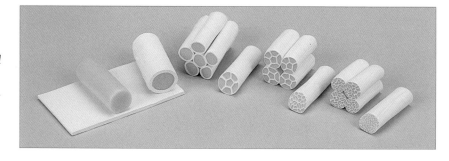

JELLYROLL CANE

For a jellyroll, layer two or more sheets of clay and taper one edge by rolling it flat. Starting at the tapered edge, roll tightly. Follow standard reduction techniques to reduce the cane. Every slice will have the familiar jellyroll pattern.

CHECKERBOARD LOAVES

The checkerboard appears as an element in many complex canes. There are two methods to construct a checkerboard cane: with snakes or with slabs.

Snake Checkerboard

Roll five light snakes and four dark. For the first row, place one light snake on each side of a dark one. For the second row, reverse the arrangement so that a dark snake sits on either side of a light one. To complete the checkerboard, place the remaining two dark snakes on either side of the remaining light one. Follow standard reduction techniques to reduce the cane.

Slab Checkerboard

Layer two equally thick slabs of contrasting colors. Cut this simple loaf into slices; the width of the slices should equal the thickness of one slab. Separate and reassemble the slices by turning every other one upside down so that the colors alternate on both sides of the loaf as well as on top and bottom. Follow standard reduction techniques to reduce the cane.

The spiral appearance of the jellyroll cane can be almost hypnotic. The cane can be constructed from two layers of equal thickness, or for a different look, make one layer thinner than the other.

As a graphic element, the checkerboard can have a powerful impact. The snake method of assembly begins by rolling snakes in two contrasting colors and stacking them alternately. For the slab method, start with two colors rolled into thick slabs, then assemble them into a checkerboard pattern.

PINWHEEL LOAF

For a pinwheel loaf, form two square loaves of contrasting colors. Set the loaves on end and cut them in half diagonally with a tissue blade. Separate the loaves and reassemble as pictured. Reduce this rectangular loaf, cut in half lengthwise, and again reassemble as pictured.

CHEVRON LOAF

Like the slab checkerboard, the chevron loaf begins as a rectangular loaf composed of layered sheets of contrasting colors. Set the loaf on one side and score it on the diagonal with a hair pick or Marxit tool. Using the scored lines as a guide, slice the loaf on every other line. Separate the pieces and reassemble the loaf, turning every other slice upside down, making sure that the colors meet in a crisp "V" to create the chevron pattern. For a smaller, tighter pattern, slice on every line created by the hair pick.

The pinwheel loaf is made with two square loaves that are cut at an angle, reassembled, and reduced, then cut and reassembled again.

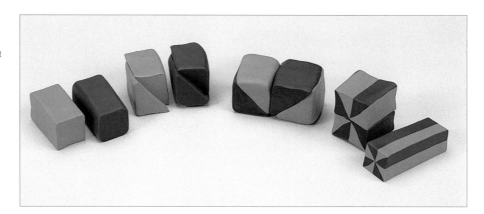

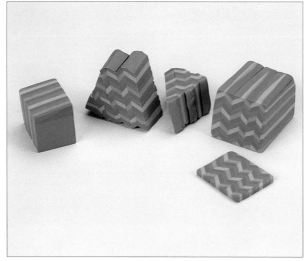
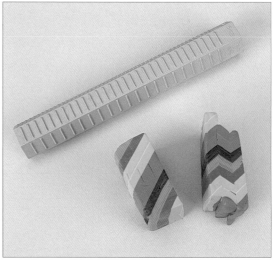

The slices in the chevron loaf must be placed together carefully for a clean zigzag pattern. To ensure slices of even thickness, use a Marxit tool to impress cutting guidelines, or score the surface with a hair pick.

PLAID LOAF

Plaid patterns begin with a square loaf. Set the loaf on end and slice it in half top to bottom, parallel to the sides. Separate the two halves and insert a sheet of a contrasting color between them. Trim away the excess clay and rejoin the two pieces. Continue cutting (each time perpendicular or parallel to the last cut), inserting, and rejoining until you've achieved the desired pattern.

SHADED CANES

Shaded canes are achieved by lightening or darkening a color by mixing it with gradually increasing proportions of another color, or even two others. As seen in the leaf cane, shading from yellow to green begins with a pure yellow to which a gradually increasing ratio of green was added for each successive layer of the bull's-eye cane, ending with a pure green. The shaded cane was then reduced, reshaped, and assembled to form the leaf.

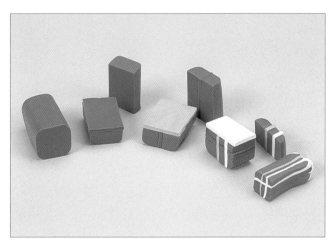

Plaid patterns make interesting beads and backgrounds. With practice you may even be able to approximate the pattern of a particular tartan or kilt.

Interesting results can be obtained by mixing incrementally larger proportions of white or black (or any other color) into a starting color. Begin with a core of the basic color, then wrap it with successive sheets of each blended shade, progressing gradually from light to dark or from dark to light. The highly detailed forest scene (right) incorporates numerous examples of shaded canes.

CANES WITH RADIATING PATTERNS

Despite their complex appearance, canes with radiating designs—in which elements are arranged around a central axis—are really quite simple to make. To make a six-petalled flower, for example, begin by making the center (perhaps using a reduced lace or jellyroll cane), then construct one large petal cane. Reduce the petal cane until it equals the diameter of the center cane, cut it into six pieces, and arrange these reduced petals around the center (they should fit perfectly). Wrap the whole assembly with a sheet (of the same or a contrasting color) and press the sheet into the spaces between the petals with a needle tool to remove air pockets and make the mass as compact as possible. Fill the spaces between the petals with snakes of the background color, then wrap the entire cane with a sheet of background color. Follow standard reduction techniques to reduce the cane. If the spaces have been filled correctly, there should be minimal image distortion when reduction is complete.

SPLICED CANES

To make a spliced cane, roll each of two contrasting colors into a log. Pinch the top and sides of each to form triangular logs. Reduce each log to a length of 6 inches and then cut into 2-inch sections. Reassemble the sections as pictured, placing the points toward each other and fitting them together. Squeeze and compress the cane with your hands.

When constructing a cane with a six-petalled flower, the diameter of the center should be the same as that of the petals. This one features a jellyroll center surrounded by shaded bull's-eye canes.

The splicing technique can be manipulated to produce an almost melted-clay appearance where the two colors join each other.

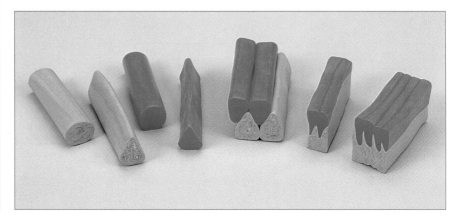

KALEIDOSCOPE CANES

Kaleidoscope canes begin with a triangular log. To two of the sides (the same two in all steps), apply snakes of contrasting color lengthwise. Once the two sides are covered, place a sheet over the applied snakes. Reduce the assemblage, cut it into two equal pieces, and trim away raw edges. Place the two pieces together with sheet sides touching. Apply more snakes over the exposed sheet sides, then place another sheet across the top. Reduce the new assemblage again and cut it into three equal pieces. Reassemble these three pieces to make a round and then reduce again.

When I discovered a method for producing a cane with a colorful kaleidoscopic image, I was pleasantly surprised to find that it was also a great way to use up the scraps of clay on my table. Kaleidoscope canes lend themselves beautifully to making patterned cabochons; begin by shaping the cabochons out of scrap clay, then cut a thin slice of your cane, place it over the cabochon, and smooth the surface.

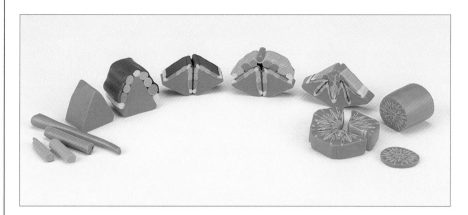

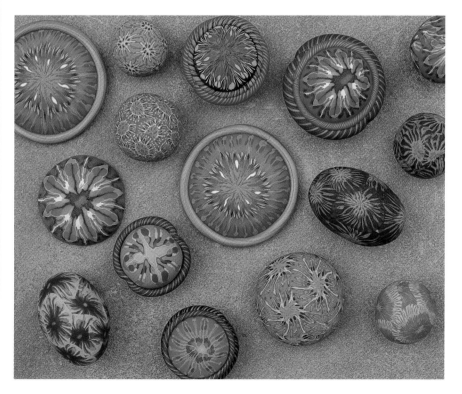

Clichy Rose Cane

This cane achieves its appearance of depth by incorporating opaque and translucent clay side by side. Begin with a bull's-eye cane composed of a yellow core wrapped with sheet of white and then a sheet of yellow. Reduce it to a 12-inch length and cut it into six 2-inch pieces. Arrange five of the pieces around the sixth and roll the cane smooth.

For the petals, create a long bull's-eye cane with a white center wrapped with a translucent pink sheet. Reduce it to about a ¼ inch in diameter and and then flatten it by putting it through a pasta machine on the thickest setting or by rolling with a brayer. Cut it into 2-inch pieces, layer them around the yellow center, and reduce the assembly.

The delicate Clichy rose cane generally starts with a yellow core wrapped with white and then yellow, though lovely effects can also be achieved with a pink core. The surrounding strips are flattened bull's-eye canes built into layers around the central core.

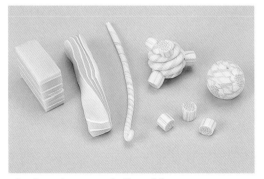

The three-dimensional effect of this cane is most obvious when the cane is thickly sliced. The beads and cabochons were created by making a layered loaf of white and translucent clay, twisting and reducing the loaf into a thin spiraled snake, and then wrapping the jewelry form with this snake. Thick slices of reduced Clichy rose cane were then smoothed onto the forms. Note the use of a pink-centered cane in the heart-shaped brooch.

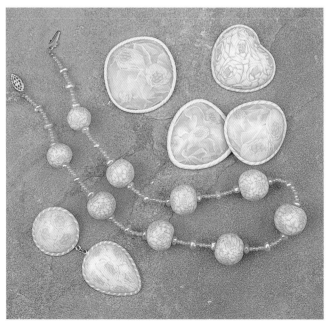

Face Canes

To the uninitiated, face canes seem mysteriously complex. But reduce the elements of the face to a series of basic shapes and the construction process begins to reveal itself. Take advantage of facial symmetry when copying its elements in clay; there are two eyes, for example, but you need to construct only one eye cane, then reduce it and cut it in half. Although you can make a face cane in any shape, a round one is the easiest to reduce, with less potential for distortion.

I always begin my face canes with the eyes, which can be a jellyroll for a funky look or a black-centered bull's-eye for a more realistic appearance. Reduce the eye cane and cut it in half for two eyes. Create all the features individually (it sometimes helps to wrap the finished feature with a sheet of the background face color) and then stack all the elements together. Wrap a sheet around the whole assembly and press the sheet into the indented areas with a needle tool, pushing the air out. Fill in all open areas with shaped wedges and snakes until an approximately circular or oval shape is reached. Wrap it with another sheet and reduce.

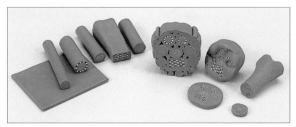

The Sculpey III face is composed of simple elements, but the color and pattern give it an unusual look. Once reduced, the cheeks and eyes maintain their roundness because each was first wrapped with a sheet of the face color, and the air pockets were also filled with snakes of that color.

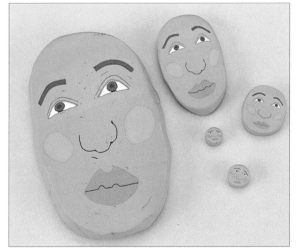

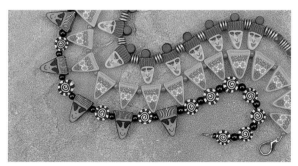

Face canes need not be round—pinch them into triangles, reduce, and slice off pieces to serve as beads. All three of these millefiori necklaces are made of Cernit. In the top two, opaque white #29 was added to each color; the bottom necklace faces were made without the addition of the white.

Realistic faces can be created with practice. Think of features as geometric elements: eyes are white triangular logs beside dark bull's-eyes. The nose began as a log placed between the assembled eyes; the lower part of the nose was indented with a needle tool then covered with a thin dark sheet. Bull's-eye cheeks were added, then a flesh-colored sheet was wrapped around the whole. The mouth was formed by reshaping a log and placing a black sheet between the lips. Triangular logs filled the gaps. Layered sheets formed a chin and a tapered slab created a forehead. The top of the head was covered with a sheet and snakes filled in pronounced indents along the perimeter. Reduction began by standing the cane on end and squeezing the center.

Using Millefiori Canes and Loaves

There are many ways to use canes and loaves, the most popular of which is beadmaking. Place thin slices of canes over a base bead (any mass of clay—perfect for utilizing "ugly" or leftover scraps) and then roll until the slices fuse together. Closely packed slices of uniform thinness cause little pattern distortion; thicker, more widely spaced slices result in greater distortion. This is not necessarily bad, however; thickly sliced translucent canes yield greater depth and interest. You can also create flat beads by slicing canes thickly and making hole through the slices. Either make the holes prior to baking or—for minimal pattern distortion—drill the holes with a Dremel tool after curing is complete.

To produce millefiori-patterned sheets, apply thin slices of canes to a sheet of clay. To minimize pattern distortion, try to make the slices all the same thickness and to fill all the spaces. Once the slices are all in place, smooth the sheet by rolling either with a brayer or through the pasta machine. For "painted" effects, apply extremely thin cane slices, which will make the pattern appear to be painted on the surface. You can use these sheets to cover a variety of objects, including jewelry and home decor items, or you can cover the objects with a plain sheet first, then smooth the cane slices directly onto the sheet-covered object.

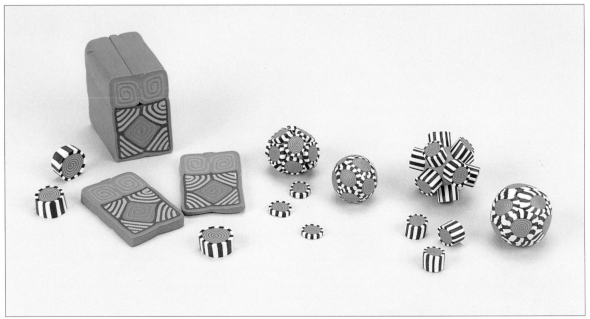

The same cane can create very different effects. Uniformly thin and closely packed, the stripe-edged cane slices retain their original shape and change very little when rolled. In the second case, once the thicker slices are rolled, more of the cane's sides are exposed, creating stripes while the centers have remained relatively unchanged.

Extremely thin slices enable you to create beautiful "painted" effects. As you selectively place your slices, the pattern on the bead will appear more and more complex.

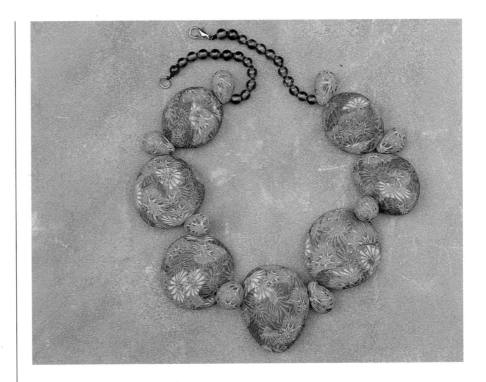

To produce elaborately patterned items such as vessels and picture frames, apply a layer of clay directly to the item, then place thin cane slices over this layer (the first layer gives the applied slices a good foundation upon which to adhere). Once the slices are all in place, smooth and compress by rolling gently either with a brayer or between your palms.

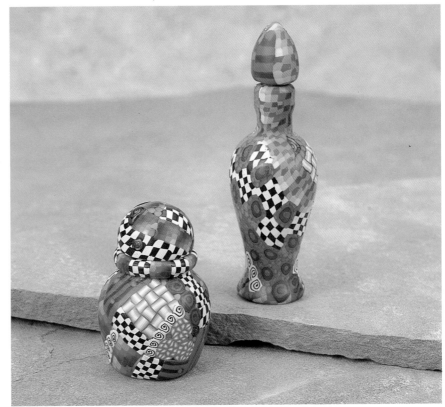

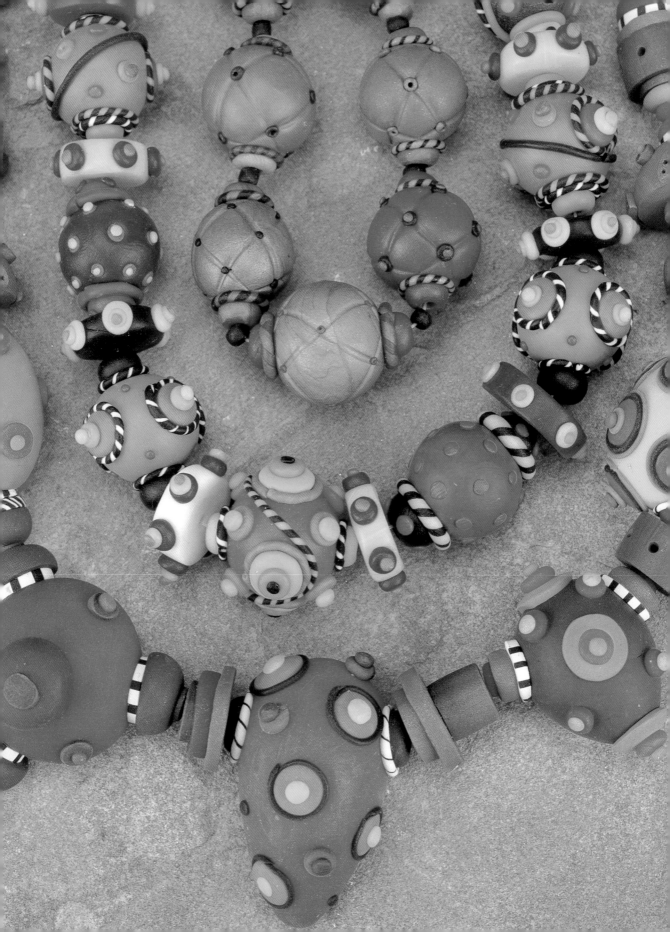

3 | Surface Treatments

Polymer clay's ability to adhere to itself and to other materials prior to curing allows for a great variety of surface treatment techniques, as do the ways it can be treated and manipulated after curing. Polymer clay can be painted, carved, sanded, or buffed. It can be onlaid with elaborate arrangements of other colors of clay, dusted with glitter, covered with metal leaf, or impressed with intricate patterns. A bit of experimentation can yield a great variety of very interesting effects.

(Opposite) Baroque beads (center and bottom necklaces) sport an endless variety of snakes, disks, and dots in a riot of color. Quilted beads (top necklace) give the appearance of tufted fabric. (Above) A collection of carved and painted polymer clay eggs demonstrates the medium's adaptability to traditional clay techniques.

Onlay Techniques

In its uncured state, polymer clay is *cohesive,* meaning that its raw materials stick to each other. As the clay cures, the bonds between distinct shapes become strengthened, eliminating the need for glue. Certain polymer clays are more cohesive than others. Cernit is the one best suited to onlay techniques; even the tiniest bits adhere strongly to each other as well as to the base surface, forming the strongest clay-to-clay bond. Though not very sticky to the touch, Fimo adheres to itself quite nicely. Sculpey III doesn't stick to itself as well as Cernit but adherence can easily be increased by brushing the clay with Liquid Diluent before pressing and smoothing two elements together. Promat is the least cohesive of the clays; the two parts must be nearly the same temperature for a proper bond. To improve Promat's bond, warm the clay by lightly rubbing the clay at the points of adherence, and/or use Liquid Diluent. Even the clays with strong self-adhesion will benefit from the warming process and the application of Liquid Diluent.

To prevent flat spots on three-dimensional beads, cure them on skewers. Either stand the skewer upright in an ovenproof cup, or lay it "spit style" across a baking pan. Cure the clay following manufacturer's directions. Because of expansion and contraction, beads cured on bamboo skewers must be removed while still warm or they will stick to the skewers. If this happens, return the bead and skewer to the oven for a few minutes at curing temperature, then carefully remove them from the skewer. You can also use metal skewers, stickpin wire, metal knitting needles, or mandrels (the metal rods used by glass artists). With any metal skewer, there should be no problem with bead removal, whether the clay is warm or cool.

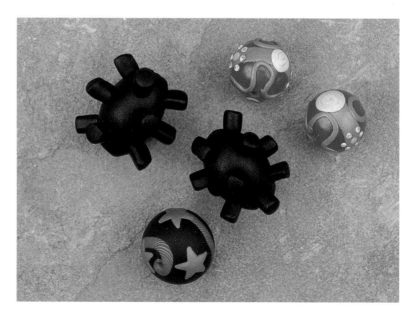

Five embellished beads illustrate just a few of the unlimited ways to decorate polymer clay shapes. The red Promat beads are patterned after traditional Venetian glass. For the black Cernit "mine" beads, indentations were made in the base beads with the end of a paintbrush, then the "arms" were pressed into them. The fifth bead utilized a tiny star-shaped cutter and a striped Promat snake.

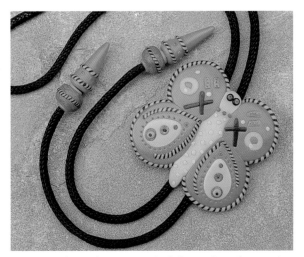

Baroque onlay techniques can be left raised, or they can be flattened with a brayer, as in the Butterfly Bolo.

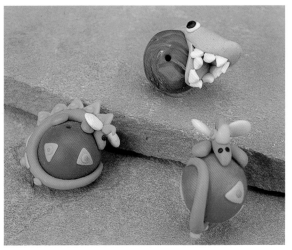

When creating dimensional objects, keep the item on a bamboo skewer as you work on it. That way you can turn and manipulate it easily without having to hold the clay directly. The skewer was removed right after baking the three Cernit dragon and shark beads.

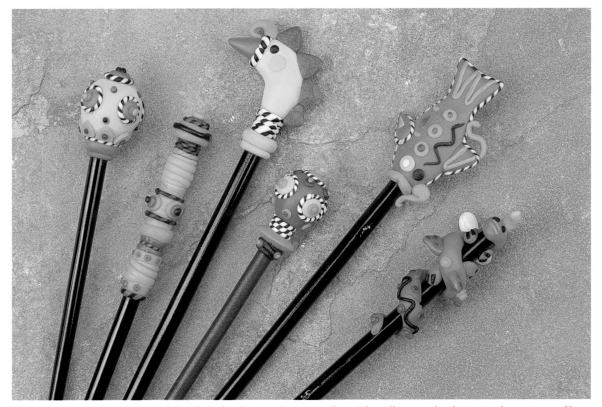

These plant spikes were built and then baked right onto decorative chopsticks. All are made of Cernit, whose strong self-adherence makes it ideal for the baroque technique.

BAROQUE BEADS

Baroque beads is a term I coined to describe the intricate detailing on certain onlayed beads, in a technique derived from glassmaking. By working with the bead on a bamboo skewer—thus eliminating the need to handle it directly—I was able to create dimensional beads in the round, detailing one side without disturbing the other. These techniques can be successfully employed with any polymer clay and in any colors.

Baroque beads frequently feature several different onlay elements, such as *bead caps* (clay that adorns the edges of the bead's hole) and *dots* (flattened balls of clay pressed onto the bead surface). For the most efficient bead detailing, before you begin actual construction, prepare at least some of the elements you plan to add. Consider using snakes ($1/16$ inch in diameter or smaller, either rolled by hand or extruded through a clay gun), interesting shapes cut from thin sheets (either with a blade or a tiny cutter), and multicolored dots (formed from small balls of various sizes, flattened between your thumb and forefinger). Striped snakes—quite effective for bead detailing, especially in black and white—are easily made by rolling a 3-inch snake in each of two colors, $1/8$ inch in diameter. Place the two snakes side by side and twist their ends in opposite directions. Roll until smooth, then reduce to $1/16$-inch diameter.

With your chosen skewer, "drill" a hole through a mass of clay in the desired shape of your finished bead. Holding the skewer, press flat shapes and bits of clay onto the bead. If you want to use bead caps, they must be added before the body of the bead is embellished. To make bead caps, roll two small balls. Drill through one of the balls with the tip of skewer, then push the ball down the skewer and press it onto the base bead. Withdraw the skewer and redrill it through the capped end of the hole. Drill the skewer through the other small ball, then press it down on the bead's opening.

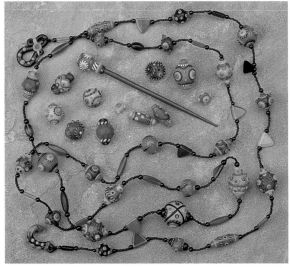

Baroque beads begin as simply as any other kind: with a ball of clay, either left round or formed into another bead shape. The elaborate appearance results from adding a collection of different onlay elements, including bead caps, dots, and tiny snakes. Prepare these elements before you start decorating the beads so your work will flow smoothly.

For added interest, encircle the holes with thin snakes, trimming neatly to form a butt joint. To create a cone-shaped embellishment, stack a series of progressively smaller dots, then place a tiny ball on the top. Wrap thin snakes around the base of other onlay shapes, crisscross them over the bead, or wind them around the bead's circumference.

QUILTED BEADS

By pressing the side of a needle tool into the surface of an uncured bead, you can simulate the dimensional contours of quilted fabric. As with the baroque technique, work with the beads on a skewer to ease manipulation and minimize handling, and set the bead caps before adding other details. Use the needle tool to poke four equidistant holes around the bead's equator. (These holes should not penetrate too deeply; they're really just indentations.) Make a second set of holes above the first, spaced at halfway intervals between the first set but following a line halfway between the equator and the bead caps. Repeat on the lower half of the bead for a total of twelve intersections.

To create the quilting line, place the side of the needle tool on one of the equator holes. Applying firm pressure, roll the needle tool to incise a line, connecting the first hole to one diagonally above it to the left and extending the line beyond the second hole to meet the bead cap. Starting again with the same hole at the equator, repeat for the hole diagonally above to the right. Repeat for each hole along the equator, then turn the bead upside down and repeat.

For the accent dots, roll twelve 1/16-inch-diameter balls of a contrasting clay. Place one ball on each hole, then use the needle tool to pierce the center of each ball.

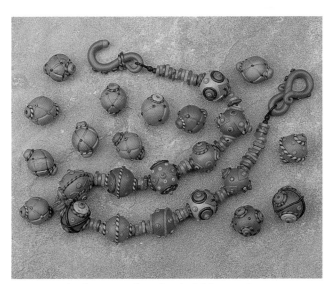

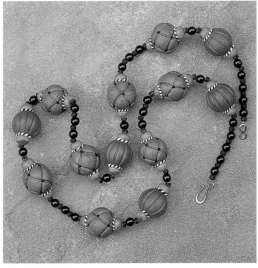

To imitate the dimensionality of quilted fabric, etch a crisscross pattern over a bead, or run lines down the bead from one hole to the other to create a tufted "melon" look.

FILIGRANA SNAKE

After seeing a demonstration on glass bead making, I realized that by utilizing a combination of translucent and opaque polymer clay, it would be possible to create a filigrana snake. Unlike ordinary striping, which lies on the surface of the item, filigrana stripes actually run through the center of the snake. Begin by making a striped loaf consisting of layers of translucent clay alternating with colored clay. Pinch and press the corners of the loaf to round them off, then roll and twist the loaf into a smaller diameter snake. The opaque stripes form helixes inside. Beads made with this technique provide an interesting contrast to the baroque method.

BALINESE FILIGREE

The ornate, beautifully detailed articles of traditional Balinese jewelry feature fine granulated balls of silver or (less frequently) gold, placed on a silver or gold base bead and interspersed with fine snakes that define the pattern and separate the grains. The beads and other items I make that are entirely covered with snakes and dots I have dubbed "Balinese filigree" for their resemblance to this jewelry, though the traditional technique tends to display greater negative space than my version, in which the entire base is usually covered. The most common Balinese beads are silver, but I find that using either Promat gold or a copper made by mixing together gold and tomato red provides the richest appearance with this technique. Like the baroque beads described above, I use a skewer or mandrel to ease manipulation and maintain sharpness of detail.

Begin by forming conditioned clay into your desired bead shape, pierce it with a needle tool or a bamboo skewer, then set aside. Place a medium-size hair screen on the clay gun and load the chamber no more than half full with clay of the same color as the bead. Extrude long strands, cut them off at the screen with a blade, and carefully separate each strand. Tightly roll the end of an extruded strand and place it on the base bead. Slowly rotate the bead while patting the strand to the surface to ensure that it adheres. Continue coiling and patting the strand until you've created the desired shape, then cut off the leftover end of the strand.

For beaded edging, extrude very short lengths of clay from the clay gun and cut them off at the screen. Separate the bits and roll each into a ball. Arrange them on the base bead side by side to form curving lines, then pat lightly to secure. If desired, indent each of the balls with a ball stylus. To create a coin-edge design on selected strands of coiled clay, use the tip of a needle tool to imprint closely spaced, parallel impressions. Once the base bead is completely covered with designs, cure it in a preheated oven at 275°F for 30 minutes per $1/4$ inch of thickness. As with baroque beads, be sure to bake the beads on a skewer so the design will remain fully dimensional.

The patterning of items made with the filigrana snake appear more dimensional and markedly different from those using surface striping.

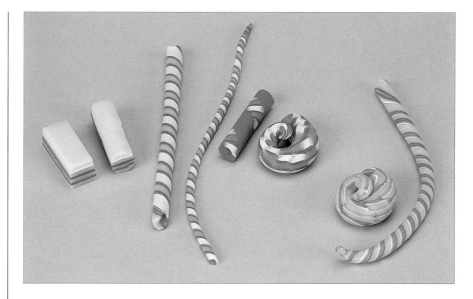

Although polymer clay renditions of Balinese filigree look complex, they are quite simple to make. Their freeform designs gradually evolve as the base is onlaid with detail. The sinuous coils result from tightly rolled individual strands of clay. The tiny "grains" are bits of extruded clay rolled into little balls.

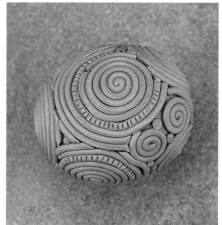

Start with a base bead of the same clay that will be used for the surface decoration. Add closely wrapped coils, multiple wavy lines, and rows of "grains." The finish details described in chapter 1 for use in cabochon settings—especially beaded, cupped beaded, and coin edging—lend themselves beautifully to this technique.

Image Transfers

Certain types of images can successfully be transferred to polymer clay. Black-and-white or color photocopies (those made with toner, not laser copies), most types of black-and-white newsprint, and designs drawn on tissue paper with colored charcoal pencils are all candidates for this technique. You can generally get about five transfers from the same black-and-white copy; a color copy will usually yield up to three impressions. Since color copies are composed of several layers of colored toners, the first transfer may be a little greener than the original image, the second somewhat pinker, and so on. You can adjust the color of a transferred image with powdered eyeshadow or blush. Keep in mind that this process produces a mirror image of the original, so any writing transferred will appear in reverse on the clay. For the crispest image, use white or other light clay, but other colors will also yield interesting transfers.

To transfer an image from a photograph or a book of copyright-free designs, for example, make a photocopy of the image you wish to transfer. Place the photocopy face down on a sheet or slab of clay and rub your fingers over the whole image to eliminate any air bubbles. To ensure full contact, roll a brayer over the paper, or burnish it with the bowl of a spoon. Allow it to sit for 15 minutes to an hour. Bake normally, then remove the paper. If you want the transferred image to appear on a curved rather than a flat item, shape the object first then tightly wrap the image around it and secure with tape before burnishing and baking.

 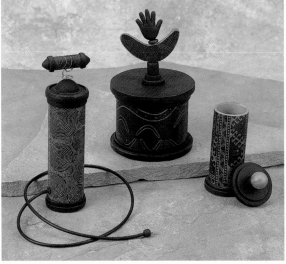

The image transfer process yields results quite different from other polymer clay techniques. The books began with copies of my original drawings transferred onto flat sheets of clay. Making the cylindrical boxes was slightly more complicated than transferring an image to a flat form. Once the clay vessel was formed, the photocopy was then wrapped around the clay very tightly, taped, and burnished. After curing, the image paper and the interior cardboard were removed. A bottom was constructed and the piece was baked again and cooled. When fabricating and fitting the lid, the vessel's top edge was wrapped with plain paper to prevent the clay from sticking to the transferred copy. The whole piece was then baked once more.

Working with Glitter

The simplest, neatest way of controlling glitter when you work is to shake a portion into a sealable plastic bag. Drop in a ball of raw clay, shake, and carefully remove the clay. It's best to conduct the entire operation away from your clay station, or you're likely to have glitter all over everything. Once you remove the glitter-coated piece from the bag, roll it in your hands, pressing the glitter into the clay. After curing, glitter-coated pieces should be sprayed with a protective acrylic glaze.

The Promat bracelet was made by reshaping glitter-coated balls into loose spirals and then "drilling" holes into the thick ends of the spirals before curing. After they cooled, they were strung on elastic.

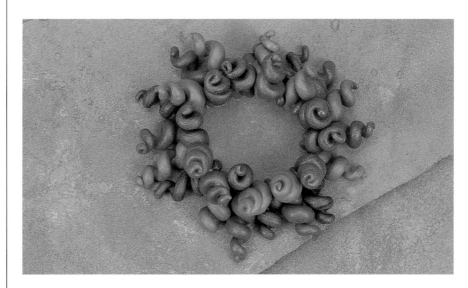

Beads of Sculpey III were covered with glitter of various colors and cured. After curing, dots of squeeze-bottle paper paint were applied, then the beads were given a coat of gloss-finish Sculpey Glaze to seal in the glitter.

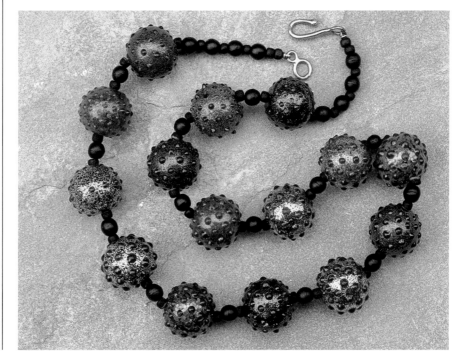

Metal Leaf Treatments

Metal leaf adds glamour to jewelry and articles of home decor. The extreme delicacy of metal leaf means it is easily disturbed by moving air, so make sure the room in which you're working is draft free. Try to handle the leaf as little as possible. Some artists wear white cotton gloves when working with leaf; others use two clean, statically charged brushes to move the leaf from its booklet to the surface. I generally use an index card to pick up the leaf and slide it onto the clay, but some prefer to place the clay directly on the leaf. Experiment with all these methods to see which works best for you, but be gentle. Also keep in mind that although the clay stretches, the leaf does not, so if you want a more solid look (rather than a crackled effect), take care not to manipulate the clay too much once the leaf is applied. For more general information on metal leaf, see pages 25–26.

When metal leaf is mixed into the clay, it produces a delicate flecked look. For the crackled pattern seen on the Promat picture frame, place the leaf on top of a clay sheet and roll it through a pasta machine.

To imitate golden burl, a mixture of gold and translucent clay was overlaid with gold leaf and rolled into a jellyroll (which was not reduced, to avoid cracking the leaf), then very thinly sliced at a 45° angle. The slices were overlapped on a translucent ball and rolled smooth.

The four small vessels were adorned by placing a layer of leaf on a sheet of clay and covering it with a thin layer of translucent clay; the vessel was then covered with this leaf sandwich. For the larger vessel, the leaf sandwich was sliced into strips and arranged over the surface.

APPLYING METAL LEAF

1. Roll a sheet of clay 1/8 inch thick. Open a book of metal leaf and gently place the clay on the leaf. (See Photo 1.)

2. Carefully lift the clay (the unused part of the leaf will easily tear away). Turn the clay over and smooth the leaf onto it. (See Photo 2.)

3. Roll a sheet of translucent clay on the smallest setting of the pasta machine, or roll it by hand as thin as possible. Lay it over the other sheet of clay, sandwiching the leaf between the first sheet and the translucent one. Gently pat the translucent sheet to adhere it to the leaf. (See Photo 3.)

4. Roll the clay-leaf assembly through the largest setting of the pasta machine. Rotate the clay one-quarter turn, then roll it through the machine on the next smallest setting. Continue this process until you achieve the desired crackle pattern, resetting the machine one increment smaller each time. (See Photo 4.)

5. The resulting sheet of clay can be used for a variety of projects, such as home decor items or jewelry. (See Photo 5.)

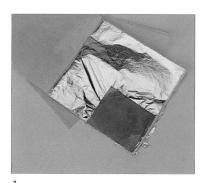

1

2

3

4

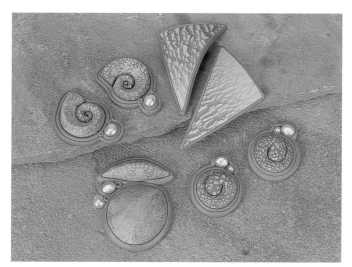

5

Manipulating Cured Clay

In addition to the many modeling and texturizing options of uncured polymer clay, there is growing interest in surface treatments of the medium after curing. Cured polymer clay can be carved, sanded, drilled, buffed to high sheen, glazed, painted, or treated with a combination of any or all of these processes. Painting does not require prior sanding, but sanding always precedes glazing or buffing, and follows painting when "antiquing" a piece. The following sections detail carving (one of my favorite techniques), sanding, buffing, glazing, and painting. For information about drilling, see page 34; for glazing, see page 23.

CARVING

Although it is quite firm, cured polymer clay can be carved easily. Unlike wood, polymer clay has no inherent grain, which makes the actual carving much easier. Since the clay offers minimal resistance, you need only hold the carving tool (see page 24) as you would a pen or pencil, gripping the piece firmly in your other hand. To avoid cutting yourself, always direct the blade *away* from your hand and body. As you carve, try to keep cuts the same depth by not digging the blade into the clay past the top edge of the gauge. If you desire a deeper cut, select a larger gauge. Remember that warm clay is easier to carve than cold clay.

Some brands of clay are better suited to carving than others, so you should experiment with what you have on hand before you begin a carving project. Promat, Cernit, and Fimo carve beautifully; the shavings come off in long strips. Sculpey III is a more brittle clay and therefore tends to chip as you carve, but a very sharp carving tool helps alleviate this problem. In general, carved areas tend to be lighter and duller in appearance than uncarved spots, but returning the piece to the oven (for about 10 minutes at the original temperature) after carving and sanding helps restore the color somewhat.

To carve a complex or intricate pattern (or even to practice carving a simpler one), lightly score the design onto the surface with a needle tool prior to curing. Then, if you make a mistake, all you have to do is rub lightly to erase the design, then begin again. After the piece has been cured, simply carve the pattern following the scored guidelines.

Wonderful wooden and ethnic looks can be achieved by carving cured polymer clay (in this case, Promat) and applying heavy washes of burnt umber or raw umber acrylics. After the piece is completely dry, buff either with an electric buffer on a medium speed or with a soft cotton cloth.

The layered look of these four beads resulted by carving the base, pressing Promat into the carved areas, and covering it with a thin sheet of translucent Sculpey III. After partial curing, the process was repeated: carve, press in contrasting clay, cover with translucent clay, then complete the curing.

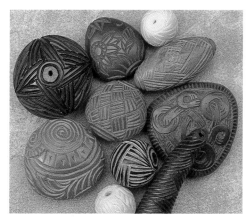

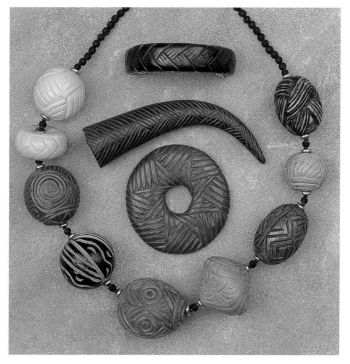

These beads (above and right) were all carved after curing. Several of them—such as the long ochre bead, the central red bead, and the black bead below it seen in the random grouping—were created by carefully fitting base beads with sheets of thin layers of contrasting colors; carving exposed the lower colors for a two-toned effect. Several of the beads were painted after carving, then aged by sanding and buffing after the paint dried.

SANDING

Sanding smoothes the surface imperfections that would otherwise be amplified by the application of glaze; it also enables you to impart the greatest sheen to your pieces with a smaller expenditure of buffing time. Keep in mind that if you sand a piece but do not buff it, the surface will appear duller than before the sanding. And the better your sanding job, the easier it will be to buff the piece.

WARNING: Inhalation of polymer clay dust is hazardous. To prevent it from becoming airborne, always sand under running water, or wet the sandpaper and work over a sink or bowl filled with water to catch the dust. As an extra precaution while sanding, wear a particle mask (found in hardware stores).

Under running water, begin sanding with 400-grit wet/dry sandpaper (do *not* use regular sandpaper with water). Once the major roughness is gone, switch to 600-grit (the larger the number, the finer the paper). When the piece is as smooth as you want it, dry it off, then it's ready for buffing.

If you've ever refinished furniture, you can appreciate the necessity of sanding before painting if a smooth finish is desired. Sanding provides an even, smooth surface on which to apply your paint. Not every piece destined for painting requires sanding, however. The Celtic pieces, for example, were carved in deep relief and were meant to have a rough finished appearance, so they were not sanded. In other words, let the final effect desired for a specific piece dictate whether you sand prior to painting.

A piece that will not be painted but will be buffed benefits after sanding from a return to the oven for ten minutes at the original temperature. (Be sure to let it cool before buffing.) The additional curing seems to improve the shine of the finished piece. For even greater sheen, recure after buffing and buff again.

For an antiqued effect, paint the entire piece, then sand off the excess. Once the Sculpey III netsuke goat was cured, it was sanded, given a medium-thick coat of dark acrylic paint, and then resanded after the paint dried. This leaves paint only in and around the deeply carved areas. After sanding, the piece was buffed to bring up the clay's natural sheen.

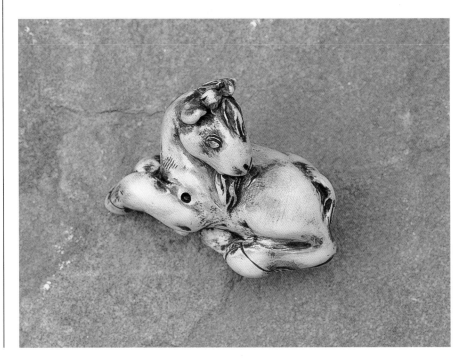

BUFFING

Buffing is an excellent way to impart gloss and luster to a cured piece, an alternative to using brush-on or spray-on acrylic glaze. I use a variable-speed bench grinder fitted with a muslin wheel (see page 23). Before buffing, sand the piece as described above to smooth any surface imperfections. Begin buffing at a low to medium speed, lightly touching the piece to the wheel while moving it in small circular motions, achieved by rotating your wrist slightly as you bring the piece in contact with the wheel. Use a very light touch; applying too much pressure will cause scratches and the heat from the machine may even melt your piece. As you acquire more experience, set the speed higher to achieve a greater shine. If a very high sheen is desired, bake the piece again (for five minutes at the original temperature) after buffing, then rebuff.

Hand Buffing and Acrylic Finishes

If you don't have a buffer and feel that the volume of your polymer clay work won't justify the expense, you can achieve almost the same effect by sanding your piece as described above, then rubbing it first with a paper towel, then a soft cloth, either cotton, linen, or denim. As with the electric buffer, bake the piece again briefly and then rebuff to achieve a higher gloss.

The only way to achieve a truly comparable sheen without the use of an electric buffer is the combined use of sanding followed by an application of either Future Floor Wax or Beacon Liquid Laminate, which result in a hard acrylic finish. Apply the chosen finish with a brush, let the piece dry, then buff with a soft cloth. They will impart a sheen without the gloppy look that accompanies many glazes.

The intertwined Celtic patterns were first lightly scored onto the clay, which was then partially cured. The designs were then easily carved, and after curing was completed, the clay was painted and then buffed by hand with a soft cloth. To retain the rough-carved look, no sanding was done.

PAINTING

Cured polymer clay requires no special preparation for painting with any brand of water-based acrylic paint. For the most uniform coverage, select high-quality tube acrylics (such as those manufactured by Golden, Liquitex, and Winsor & Newton); these will yield much better results than the less expensive craft acrylics, which have a chalky texture and offer inferior coverage and finish. Rather than applying a thick coat, which might peel, water it down to the consistency of thick cream and, if necessary, apply a second coat after the first dries. Mistakes are easily fixed: if the paint is still wet, simply wipe it off with a wet paper towel; if the mistake has already dried, it can generally be covered by applying more paint.

Since acrylic paint dries very rapidly, manipulating colors on a piece is quite difficult. As a first project, try an item of one uniform color with minimal sanding and buffing. If you do want shading, apply the paint in very thin washes. (Don't choose transparent paint for this process; stick with high-quality opaque acrylics and dilute them with water.) Add layer upon layer to build color intensity. For further color subtleties—such as that often seen on duck decoys—paint darker areas of color first, then apply the wash after they dry. This will soften the effect so the dark spots seem part of the scheme rather than afterthoughts placed on top of other colors.

Oil paints can also be used, but the clay should first be isolated with a protective layer of acrylic glaze. If you plan to use oils, always test the paint on a cured scrap piece; some brands of oil paint actually dissolve polymer clay.

The small bird sculpture (near right) and the fishing bear (far right), which was patterned after a traditional Japanese carving given to me by my grandmother, both began as shaped masses of foil covered with a layer of Super Sculpey. The bird was textured prior to curing, while the bear was carved after. They were then lightly sanded, painted with a medium-heavy wash of raw umber acrylic, and then buffed with a soft cloth after the paint dried. This type of project, entailing no color mixing, is good practice for working with paint.

The dragon sculpture—made of Sculpey III scrap clay and textured with a ball stylus—was painted (after curing) with medium-thick, quickly applied coats of acrylic paint. A thin wash of Renaissance gold paint imparted a golden glow to the skin of the dragon and baby.

Bakelite

Bakelite is the trade name of a synthetic plastic developed in 1907 by chemist Leo Baekeland. Baekeland could well be called the father of polymer science, for without his pioneering work, polymer clay might never have been invented. Bakelite is a thermoset plastic; when exposed to heat and pressure, it is permanently altered from its initial form and cannot be returned to its original state. First used as an electrical insulator, Bakelite was to find widespread appeal as a medium for making jewelry and buttons.

Synthetic plastic materials greatly improved in the late 1920s. Brighter colors—in both transparent and opaque hues—offered successful imitations of gemstones and amber. And not only could plastics imitate materials occurring in nature; they also gained popularity for their own unique appearance.

The Bakelite-inspired jewelry in this section demonstrates how close polymer clay imitations are to the real thing. Genuine Bakelite was often intricately carved; the same can be done with polymer clay. For my polymer reproductions, I often make molds from my original polymer pieces. To achieve the characteristic sheen of Bakelite, I finish my pieces with sanding and buffing techniques. For more ideas on re-creating this wonderful jewelry, consult *Plastic Jewelry* by Lyngerda Kelley and Nancy Schiffer.

Traditional Bakelite was often carved and made into pins, similar to the acorn and floral motif Cernit and Promat imitations (near right). Real Bakelite was sometimes painted to accentuate the cuts, much like the "antiquing" technique. For the Cernit cactus pin (far right), the sculpted components were adorned with a flower cut from a thick sheet with a Kemper posie cutter. After curing, the piece was carved with U- and V-gauge tools, then given a golden wash.

Polka dots were a popular motif on Bakelite bangle bracelets. For the two black bracelets, the holes were cut in the uncured form; after curing, clay was placed in the holes and the pieces cured again. For the yellow and red bracelets, holes were carved after the first curing, filled, then the pieces rebaked. The two pieces on the left are Cernit; the two on the right are Promat.

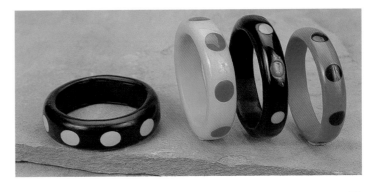

AMBER BAKELITE BRACELET

To reproduce the carving on authentic Bakelite, I utilize U- and V-gauge tools. For the amber color, condition yellow, orange, white, and gold Promat, then roll each into a ⅛-inch sheet with a roller or pasta machine. Using a medium-size cutter of any shape, cut out 14 pieces of yellow, 3 pieces of orange, 3 pieces of white, and 3 pieces of gold and knead together until well blended.

Roll the amber mixture into a snake 9 inches by ⅝ inch. Curve it into a semicircle, place on a sheet of plain paper, and flatten to a width of 1 inch. Trim the ends with a sharp blade. (Most bangles begin as 9-inch cylinders, which will fit over the average hand. If your hand is much smaller or larger, adjust the size accordingly. To get an accurate measurement, find a bangle that fits you well. Place it on a piece of paper and trace the inner opening. Lay a piece of string on the exact outline and measure it.)

With a needle tool, lightly score the pattern on the bracelet. Map out the gridded sections first, then add the curves. Trim a 1-inch eye pin, leaving a ½-inch stem, and turn the straight end to form another eye. (Eye pins, widely used in jewelry making, are available in bead and craft supply stores. You can also use craft wire, forming an eye at each end.) Insert one eye into one end of the bracelet, then bring the other end of the bracelet around and imbed the other eye in it. Smooth the joint until the seam is no longer visible.

To assure that the bracelet forms an even, regular circle, draw a 2½-inch-diameter circle with a compass on a piece of plain paper. Place the bracelet on the circle and match its curve to the drawn circle. Bake for 30 minutes at 275°F. Remove and let cool. Holding the cured bracelet firmly, use a smaller V-gauge to make even cuts in the gridded sections approximately ¹⁄₁₆-inch deep. Use a larger V-gauge to cut the curved sections. Begin each cut at an interior point, cutting outward toward the sides. As you cut, tilt the gauge slightly, carving deeper and wider as you move toward the side of the bracelet. Follow the cut completely through to the side so that when viewed straight on the sides appear notched. (Always aim the blade *away* from yourself.)

When carving is complete, recure the bracelet at the same temperature for 1 hour. Remove and cool. Under running water, sand the bracelet first with 400-grit and then 600-grit wet/dry sandpaper. Dry and buff to a high sheen.

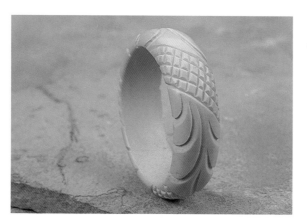

Real Bakelite frequently features elaborate carving. This amber-toned Bakelite imitation was made by carving cured Promat with a pattern copied from an original piece. After curing, carving, and recuring, the bracelet was sanded and then buffed to a high sheen.

BLACK CUFF BRACELET

Because of its flexibility, Promat is the ideal choice for this piece. You'll also need a metal cuff (available from a jewelry supply outlet and at some craft stores), bent to fit comfortably on your wrist.

1. Roll conditioned black Promat into ¼-inch sheet. If you use a pasta machine, stack two sheets of clay that have been rolled through the #1 setting on the machine. Place the prepared clay over the cuff and cut to fit the cuff exactly. (See Photo 1.)
2. Roll another sheet of clay ⅛-inch thick. Place it over the clay already on the cuff and cut to fit exactly. Remove this second sheet and lay it flat on your worksurface. Lightly score your design on the clay and cut out the shapes with a needle tool. You can also use small cutters. (See Photo 2.)
3. Place the cut-out sheet on the cuff, carefully aligning the edges. (See Photo 3.)
4. Roll the surface with a brayer to ensure full contact with the first layer of clay. Roll the edges next, rounding them slightly and integrating the two layers. (See Photo 4.)
5. Bake in a preheated 275°F oven for 30 minutes. After the bracelet cools, remove the metal cuff. Sand to remove any rough edges, and buff to produce a slight sheen. (See Photo 5.)

1

2

3

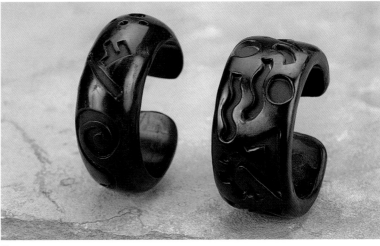

4

5

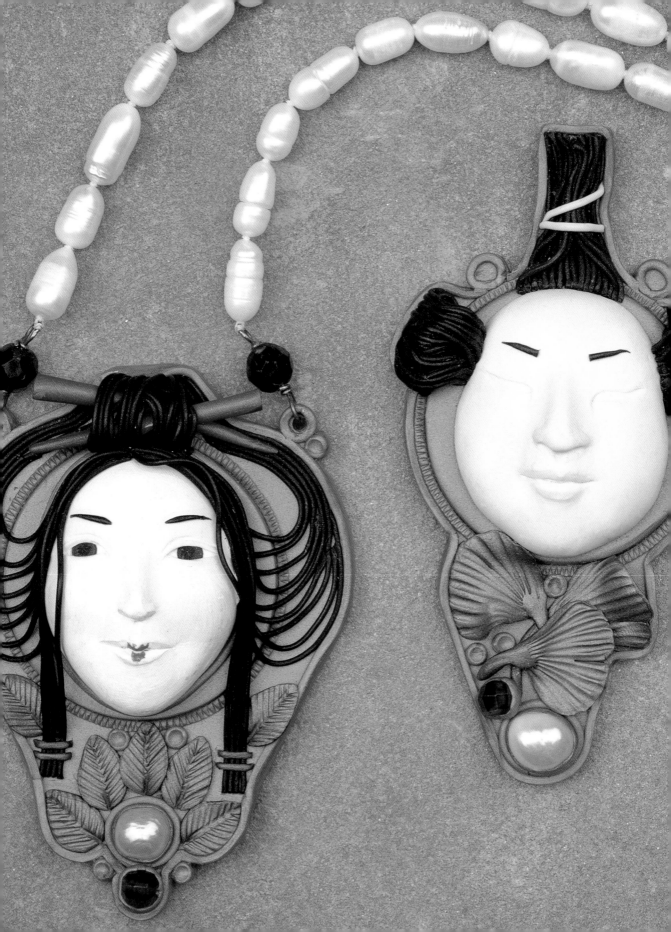

4 | Making and Using Molds

(Opposite and above) Faces cast from
polmer clay molds were given clay
gun hair and decorative accents, then
turned into pendants.

Polymer clay is a wonderful moldmaking medium. The basic method yields excellent results applicable to a wide range of projects, and the molds can be used again and again. Molds are ideal for reproducing an object whose shape or detail you want to duplicate, such as a doll's face or a beautiful carved button. Molds can also be real time-savers in projects requiring repetition of the same form or pattern.

Moldmaking Basics

A releasing agent is needed to prevent clay from sticking to the inside of the mold. Armor All— manufactured as a car-care product—works extremely well for this purpose.

Both the process of moldmaking and its material requirements are very simple. In addition to the object you're planning to reproduce, you'll need some polymer clay (this is a great way to use some of your "junk" clay) and a releasing agent. Ideally, the object from which a mold is cast should be of low relief with no *undercuts,* which are notches or open areas within or beneath projecting details, such as nostrils or an open mouth. As potential traps for clay, undercuts can distort the mold and thus the quality of the reproduction. Undercuts can generally be filled in with clay prior to molding, then restored in the reproduction with a needle or sculpting tool before curing.

As a releasing agent, you can use talcum powder, water, or (as artist Marie Segal recommends) the car-cleaning product Armor All, to keep the clay from sticking to the object. Whenever you use talcum powder, dust both the object to be molded and the clay itself with the powder. Water and Armor All can either be lightly sprayed on the object or dabbed on with a saturated cotton ball.

Hard-sided molds can be made using Sculpey III, Cernit, Fimo, and Promat. Super Elasticlay, which retains a rubbery squeezability after curing, yields flexible, soft-sided molds whose walls can be opened slightly to ease release of the object. Soft-sided molds are useful when you want to remove the mold from around the object, rather than removing the object from the mold.

Begin by conditioning enough clay so that the walls of the mold will be $3/8$- to $1/2$-inch thick. (It may take a few tries to establish the correct volume of clay needed.) Roll the clay into a ball, then form it into a thick, flat pancake. Apply your chosen releasing agent as directed above. If the object is flat-backed, place it on a piece of paper on top of a flat surface. Press the clay onto the object, applying even pressure over its surface, beginning at its center. Carefully push down the object until it is even with the paper. If you're molding a face, push the clay down only as far as the ear line; the ears may pose a problem in releasing the reproduction from the mold and can be added later. If the object is not flat-backed, just press the clay onto the part you wish to reproduce, pushing the clay close to the sides of the object. In all cases, be careful not to lift the clay from the object until the process is complete. Once the clay is completely pressed over the object, lift both molded clay and object together, then gently remove the object from the mold, taking care not to distort the mold. Place the mold (flat side down if it has one) on the paper on your baking surface, then cure it following the manufacturer's instructions.

Using Your Molds

To use a cured mold, condition enough clay to fill the mold and roll it into a ball. Apply the chosen releasing agent, press the clay into the mold, then remove it. If the clay sticks to the mold, stick the point of a needle tool partway into the back to dislodge it. Cure as directed.

When reproducing from a mold an object such as a face with depth, polymer clay artist Maureen Carlson suggests rolling the clay into a sort of teardrop shape rather than a ball. Press the blunt point of the teardrop into the nose or other deep area of the mold, then push the remaining clay into the rest of the mold. This method better helps the clay reach into all the mold's details, preventing the formation of an air pocket that will not allow the clay to completely fill the mold.

In addition to making detailed molds such as reproductions of faces, simple molds can be made and used to save time and effort. Smooth cabochon molds will guarantee consistency in your jewelry making. I made a set of simple cabochon molds—round, oval, and triangular—that I use whenever I need those particular shapes. They not only save a lot of time and effort, but ensure that the earrings and buttons I make from them are uniform in shape and size. You can also employ molding techniques to make matching multiples of items like detailed buttons.

A further use for molds lies in creating very similar but slightly altered versions of the same original. The jade vase, for example (see page 91), sports a collection of elaborate fish, no two exactly alike. To accomplish this, rather than painstakingly sculpt each one individually, I made a mold of a carving I owned (or I could have sculpted a fish from which to make the mold). I then used the mold to cast both shallow and deep impressions. Before curing, I adjusted the fish into different curvatures, thereby increasing the impression that each one is different.

Making molds with polymer clay easily allows for multiple duplications of existing forms. The cat's head was sculpted and cured, then scrap clay was used to form a mold of the item. Once the mold has been cured, it can be used to create an unlimited number of impressions.

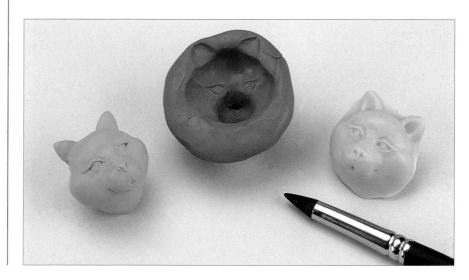

Cameos and Molded Buttons

MAKING CAMEOS

Genuine cameos are carved from shell or stone. The shells used often present subtle gradations of rosy shades below and a light ivory tone above, revealed as the artist carves away the upper layer to create the face. Cameos are easily reproduced with polymer clay molds. I created the mold for these pieces from existing cameos. When molding the original, take care to mold only the carved area, not the setting; you will construct the background and the setting separately.

Once the mold is cured, prepare the background. Place a paper-thin sheet of ivory-colored clay over a translucent rosy-colored $1/4$-inch sheet. Press the cameo mold into the clay, then remove it. With a flat, pointed wooden tool, carefully scrape the ivory clay away from the area around the image, leaving the ivory face surrounded by the rosy tone from below.

MAKING BUTTONS

Polymer clay molds offer great potential for making an unlimited variety of buttons. A matching set of brightly colored or intricately detailed buttons can dramatically change even the blandest clothing into an exciting outfit. And the set doesn't even have to match; instead of identical buttons down the front of a blouse, try using all different ones. Make your own original to reproduce, or mold a favorite existing button. Or check the button department of a good notions store. Not only will you probably find an interesting dimensional button from which to make a mold, but—since elaborate buttons can be fairly expensive—you'll most likely be able to create a whole set out of polymer clay that will cost much less than purchasing that number of actual buttons.

To make a button mold, follow the basic directions given at the beginning of the chapter. Just keep in mind that the original should not have deep undercuts. And remember, polymer clay should never be dry cleaned or put in the dryer, so any clothing with polymer clay buttons should be machine washed (or hand washed if using Sculpey III), then hung up to dry.

Forming Button Shanks

To make an integrated button shank, press into the mold a slightly larger volume of clay than neccessary to fill it. Once the clay is in the mold, carefully pinch the excess clay toward the center of the back to form a flat shank. Pierce the shank with a needle tool, then pull the button from the mold. To bake this type of shanked button, cut a hole a bit larger than the shank in a piece of heavy card stock paper or cardboard. Place the shank in the hole with the button resting on the paper, then place the paper over an ovenproof mug. If you're making many buttons, prepare a larger paper with many shank holes, then rest the sheet across a baking pan.

For a different, dressier look, you can "set" your buttons with polymer clay. The buttons to be set should have flat backs with no integrated shanks (you'll be creating a shank as part of the setting process). Cure them partially before adding the setting. Gold Promat works particularly well for these settings. Roll it out to a sheet of 1/16-inch thickness. Place the cured button on the sheet and cut around the edge, forming a circle the same size as the button. Set aside this circle. Place a 1/4-inch ball of clay on the back of the button and reshape it into a rounded cone. Center the gold circle over the back of the button. Flatten and smooth the circle onto the back of the button, covering the cone but not flattening it. With your fingertips, gently pull the gold clay toward the edge, working it up and around to the edge of the top surface, creating a bezel. The clay-covered cone is now the button shank. Carefully drill a hole through its center with a needle tool. Bake using the method described above.

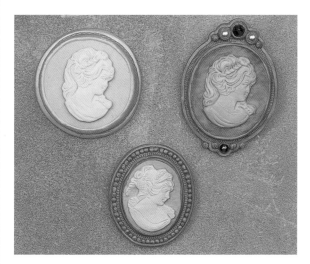

Although these cameos appear to have been carved, they were actually made by placing a molded form on a flat pancake of clay composed of two layers of Promat. The gold Promat settings were embellished with coin, beaded, and rope edging. Note the use of real pearl and garnets in the upper right setting.

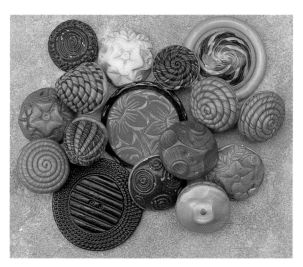

An array of polymer clay buttons demonstrates how well the medium lends itself to this application. The large black button (lower left) was produced from a mold of an authentic Bakelite button; the other molded pieces were cast by making molds of my own originals. The spiral designs were formed by coiling thin multicolored snakes of clay over a clay base.

Creating a Molded Likeness

In addition to saving time and ensuring uniformity, a mold allows you to concentrate your creative energy on making the most of a reproduction. For instance, a molded form can be transformed through color, either by varying the color of the clay or by painting the surface of a cured piece, as well as by altering its presentation and embellishing it with a variety of motifs.

In the example shown, the simplicity of the form provided an opportunity to devise an elaborate and unique presentation. I sculpted a contemplative Japanese face, cured it, then created a mold from it. (If you're not sufficiently confident in your sculpting skills to create a face from scratch, you can make a mold from a small doll's face, or purchase one of the many premade molds sold in craft and art supply stores.) I filled the completed mold with beige-pink clay for the central motif of a pendant, silhouetting it against a pewter background and adorning it with hair, eyebrows, and brightly colored robes.

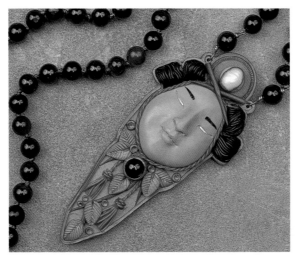

Using a molded reproduction in a project should not be a barrier to creative experimentation with the rest of the piece. The appearance of the face in the finished pendant was only one of many possible approaches with this mold. Any color could have been used to mold the face, and/or painted details could have been added. The mold could have been filled with an imitative clay, such as jade or oxydized copper. The shape and position of some of the features could have been adjusted slightly before the reproduction was cured, and the color, shape, setting, and visual weight of the pendant's other details could easily have been varied.

MOLDED FACE PIN

For this project, you will need a face mold and releasing agent; "flesh," silver, black, white, pearlescent blue, and translucent Sculpey III; a clay gun; a fine needle tool; brush-on blush; and a blending tool, such as the taper-point Clay Shaper.

1. Lightly coat the mold with the releasing agent (I used Armor All) and press the flesh-colored clay into the mold. (See Photo 1.)
2. Smooth the clay into the mold, removing any excess clay and leveling the back. (See Photo 2.)
3. Remove the face from the mold and, with a sculpting tool, refine details as necessary. Make indentations for the nostrils. (See Photo 3.)

1

2

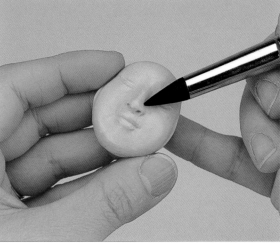

3

4. Place the face on a ¹/₈-inch sheet of silver clay. Load the clay gun with black clay and the medium "hair" disc and extrude 2-inch lengths. To form the side hair tufts, gather about half the extruded strands, pinch the strand ends together on both sides, then trim off the ragged ends. Cut the bundle in half, then place half on each side of the face, looping it to form a large curl. Use most of the remaining extruded strands to form the topknot, gathering, pinching, and trimming as shown. Create eyebrows from a single strand and place above the eyes. (See Photo 4.)

5. From the flesh-colored clay, cut an equilateral triangle whose sides equal the width of the face. Place the triangle below the face and push the points up along the lower curve of the face, following the jawline. (See Photo 5.)

6. Roll a ¹/₄-inch-diameter white snake and flatten it with your fingers to a thickness of ¹/₁₆ inch. Place over chest as shown. (See Photo 6.)

7. Repeat step 6 using pearlescent blue and positioning as shown. Roll a ¹/₈-inch-diameter blue snake and wrap it around the blue collar, tapering the ends of the snake. (See Photo 7.)

8. Make a bull's-eye cane by wrapping a log of translucent clay with a thin sheet of white. Reduce the cane to a diameter of ¹/₁₆ inch, cut about a dozen paper thin slices, and place the slices on the blue collar. (See Photo 8.)

9. Roll a thin white snake and place an "X" at the pinched part of the topknot. Load the clay gun with silver clay and the larger "hair" disc and extrude a fairly long length. Wrap a strand all around the outline of the piece. (See Photo 9.)

10. Using the needle tool, cut out the silver base around the outline strand. Tint the cheeks lightly by applying a bit of blush with a soft brush. (See Photo 10.)

11. Using the blending tool, smooth the silver snake (from step 9) into the base until they meld. Bake in a preheated 275°F oven for 30 minutes. (See Photo 11.)

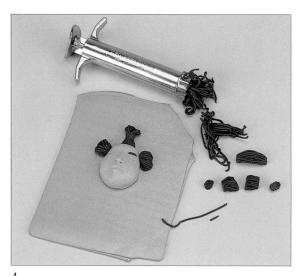

4

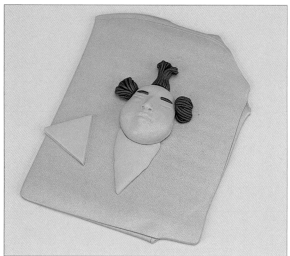

5

6

7

8

9

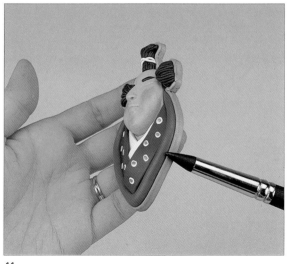

10

11

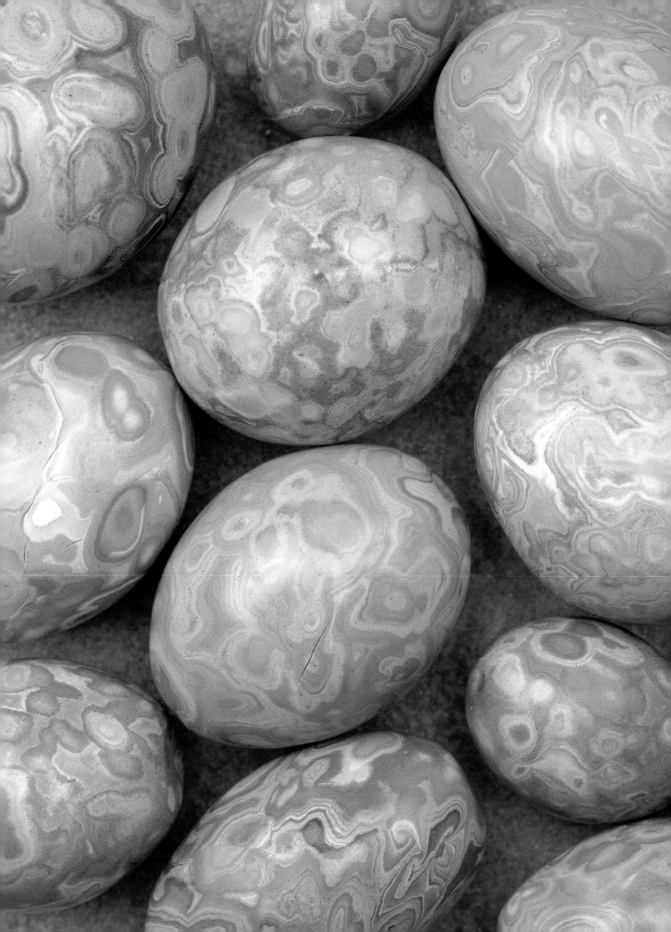

5 | Imitative Techniques

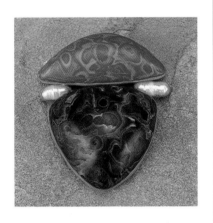

The swirls of color produced with the mokume gane technique can be imaginative (opposite), or realistic (above).

In the early 1990s, artist Tory Hughes pioneered the use of polymer clay to simulate various naturally occurring materials. Her articles on the imitation of turquoise, coral, bone, and jade, published in *Ornament* magazine, set the standard against which all polymer imitative work is judged. Her ground-breaking work established a new aesthetic in the polymer clay community, inspiring many crafters and artists to devise their own methods for imitating natural materials. This chapter covers a wide variety of my own imitative techniques, from simple mixing and marbling, to reproducing the look of semiprecious stones, to a layering and cutting technique adapted from the ancient Asian metalworking art of mokume gane.

Clay Mixing for Natural Imitations

By loosely mixing polymer clays of different colors and textures (such as Granitex), you can create some convincing imitative effects. Simple jades and agates work especially nicely when made with this method. Begin by conditioning the separate colored components, then mix them together loosely—in other words, don't blend them together completely to form one uniform color. As you mix, examine the mass, stopping when there are visbile streaks in the clay. Once the clay is loosely mixed, form it into beads, or roll it into a sheet for making cabochons or bracelets, covering vessels, or any other use requiring a sheet of clay.

THE PEBBLING EFFECT

The tendency of some clays to form small cracks or half-moon imperfections that become visible upon curing—though unsuitable in many applications—actually enhances the illusion of reality when imitating some stones, particularly jade, agate, iridescent opal, and marble. Known as "pebbling" or "plaquing," this characteristic, probably due to the presence of moisture in the clay's resins, may be dependent to some extent on the method used to condition the clay. Regardless of its cause, the effect contributes greatly to the success of these imitations. Most clays pebble, but the effect is almost invisible in opaque clays; it is fairly pronounced in transparent clays. If desired for certain imitations, it can be produced by adding water when conditioning a colored clay; this works well for some jades and marbles.

Imitative specialist Tory Hughes considers Fimo the clay best suited to imitative applications. In addition to a transparent clay, Fimo also makes one called Art Transparent, which is frequently used in imitative techniques for its ability to pebble into small half-moon imperfections. My clays of choice are Promat and Sculpey III, both of which offer a translucent clay. Translucent and ivory Sculpey III also "fracture" in similar ways, though the translucent clay pebbles more when conditioned manually, less with a pasta machine. In contrast, translucent Promat and white Cernit #010 (actually equivalent to translucent Fimo) will pebble only with the addition of water, but the results are, in my experience, unpredictable at best. All brands of polymer clay may be used for the techniques described here, but because of their specifically different working characteristics, one might be better suited to a specific technique than another. Experimentation is therefore a must.

Although the pebbling effect augments some imitations, it may be undesirable in others. If you are simulating a particular material that utilizes translucent or ivory clay and do *not* want this effect, you can add a bit of white Sculpey III to mask the pebbled appearance.

SIMPLE JADE

To create simulated jade, combine a pinch of green clay with $^1/_{16}$ of a 2-ounce package of translucent, then loosely mix this into a blend of $^1/_4$ package of translucent and $^1/_{16}$ package of green Granitex. Don't mix any of these combinations completely; if you find that the clays have been blended too thoroughly, add more translucent and loosely mix the entire mass again. This mixture lends itself to a variety of applications and works particularly well for beads, buttons, and vessels. To create a jade-look vase, roll the prepared clay into a thin sheet and smooth it over the surface of a chosen base vessel. Smooth the seams, then press paper-thin layers of translucent onto the first layer where necessary to enhance the jade look.

Simulated jade can be finished in several ways. It can be cured and left as is, or subjected to manipulations after curing. To age a piece, press coarse sandpaper over the surface prior to curing to add texture. After the item is cured and has cooled, paint the entire piece with diluted black or burnt umber acrylic paint. Rub off the excess paint, then sand it, wetting the sandpaper, not the vessel itself. Begin with 400-grit wet/dry sandpaper, then finish with 600-grit. (WARNING: To avoid inhaling any clay dust, be sure to wear a particle mask, and, to contain the dust, do your sanding above a bowl or sink filled with water. For more on sanding, see page 72.) Once sanded, buff the piece either with a bench grinder fitted with a muslin wheel, or with cloth. The better the quality of the sanding, the better and higher the sheen obtained by buffing and the easier it is to obtain the finished sheen.

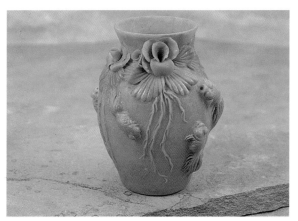

For the reproduction jade vase, a plain vessel was covered with a jade mixture, then sculptural detailing was added. All the fish were cast from the same polymer clay mold, but they were positioned on the vase in different ways to keep them from looking identical, and were smoothed into the surface so they appear to be emerging from the vessel itself.

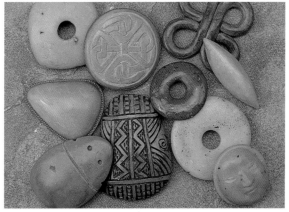

Natural jade is found in several colors, which can be approximated by experimenting during the clay-mixing stage. Modeled after traditional jade pieces, these polymer clay imitations demonstrate the many options available for finishing jade pieces, including sanding, carving, painting, rebaking, and buffing.

Sheets of Stone

Faux turquoise and jasper are made by rolling specific colors into sheets, tearing them into pieces, layering them randomly, then rolling through the pasta machine. You may also be able to produce a sheet of the required thinness using a brayer, but it may take practice.

TORN-SHEET TURQUOISE

I've used Sculpey III to reproduce turquoise, but Promat or Fimo would also work. If you choose Cernit, make adjustments for its translucence by adding white. If you wish, you can paint, sand, and buff the piece to augment the simulation. A pasta machine is highly recommended for this.

For this project, you'll need 2-ounce packages of yellow, leaf green, aqua, black, translucent, and gray Sculpey III. Should you wish to try the final finishes, you'll need 320-grit sandpaper, gray acrylic paint, 600-grit wet/dry sandpaper, and a cotton cloth or a bench grinder with a muslin wheel.

1. Mix $1/32$ of a package each of yellow and leaf green. Condition this mixture and the other clays, then use the pasta machine to roll them out as follows:
 * yellow-green mixture, on the #7 setting (paper thin)
 * $1/8$ package of aqua, on the #3 setting ($1/16$-inch thick)
 * $1/16$ package of black, on the #7 setting (paper thin)
 * $1/16$ package of translucent, on the #7 setting (paper thin)
2. Place the aqua sheet on the black sheet. Tear—do not cut—the yellow-green sheet into irregular pieces, then place them randomly on the aqua sheet. Repeat with the translucent sheet. (See Photo 1.)
3. Roll this layered sheet through the thinnest setting on your pasta machine (paper thin). Tear the sheet into strips $1/2$- to 1-inch wide and use them to cover a 1-inch diameter ball of gray clay. (See Photo 2.)
4. As you cover the gray ball, stretch and tear the strips slightly, leaving small gray areas exposed to create the illusion of veining. Roll the ball until smooth. This will result in a turquoise bead. (See Photo 3.)
5. To make a cabochon or a *Pi* (a flattened doughnut shape), place the ball good side up on a sheet of paper, then flatten it. (See Photo 4.) For cabochons, see page 38. For a Pi, shape the clay into a 2-inch-diameter disk. Use a round cutter to cut a central hole. Smooth the area around the hole with your fingers so the clay curves gently downward around the cut circumference, then recut the hole if necessary to assure a clean edge.
6. If you intend to paint the piece, lightly pit the surface by pressing 320-grit sandpaper onto the surface. Cure following manufacturer's instructions. Remove from the oven and let cool.
7. Dilute gray acrylic paint with water to the consistency of thick cream. Paint the piece and let dry. Sand it under running water with 600-grit wet/dry sandpaper, then buff with a soft cotton cloth or an electric buffer.

1

2

3

4

The coloration of many imitations can be varied slightly without sacrificing any appearance of realism. Because this necklace was designed to incorporate two distinctively yellow beads, the torn-sheet turquoise method was adapted somewhat to incorporate some yellow clay. The Pi formed from this mixture still looks like real turquoise, and it blends attractively with the accompanying beads.

MARBLE

There are many ways to create polymer clay simulations of marble. You may want to find a picture of one you like and experiment with colors and mixing methods to perfect your technique. The mokume gane technique (see page 102) can also be used to create marble looks. One simple way to achieve general marble imitations is known as marble mixing. To create black-and-gold marble, for example, begin with a log of black clay. Apply two snakes each of white and of yellow and one snake of red (each $^1/_{16}$-inch-diameter), and two snakes of gold (each $^1/_8$-inch) around the perimeter of the log. Twist and roll the ends of the log in opposite directions until a long snake with spiral stripes is formed. Fold the snake in half, and in half again. Then, to do the marble mixing, blend the clay by folding from the outer edge toward the center, repeating this twelve to fourteen times. Do not continue blending the clay into a uniform color; mix only until a pleasing swirled pattern resembling marble has been reached. You can also use this mixing method with clay composed of very thin sheets layered together.

RED JASPER

A technique very similar to the torn-sheet method will yield red jasper, using copper, black, and translucent Promat (or translucent Sculpey III). The success of the process depends on the extreme thinness of the layers. A pasta machine is highly recommended but a roller will also work. Roll the copper and black into separate sheets, each $^1/_8$ inch thick. Place the copper sheet on the black sheet and with your roller or pasta machine, reduce the combined thickness of the two sheets until it is paper thin. Cut the sheet into 1-inch-wide strips.

Roll a $^3/_4$-inch ball of translucent and wrap it with the strips, copper side out. Fold and crinkle some of the strips and leave a little of the black exposed. Roll the covered ball to smooth the folds. For cabochons, cut the ball in half to make two. Place each half on a piece of paper and then flatten and refine the shape. Bake according to manufacturer's directions. If desired, sand under running water with 400-grit wet/dry sandpaper, followed by 600-grit. Buff to bring out a sheen, then rebake and buff again, without sanding.

Red jasper, malachite, bone, and marble are just a few of the many natural materials that can be convincingly simulated with polymer clay. Bone can be produced with the same recipe as that for ivory (see page 100); the bone pieces shown here were antiqued with paint after curing.

Material Integration

Another easy method for producing polymer simulations is to mix material into the clay itself. I particularly like the embossing powders from Personal Stamp Exchange, generally used in rubber stamping. By mixing various colors of powder into the clay—translucent or colored—you can make convincing imitations of stone, jade, marble, and semiprecious gems. Verdigris powder mixed into translucent clay will produce jade. Lapis lazuli can be obtained by combining cobalt tapestry powder with translucent clay. Blending black clay with weathered white powder will yield a wonderful granite look. Note that this method sometimes requires a great deal of powder, such as for lapis lazuli; too little powder results in a paler tone and therefore a less convincing simulation. There is no specific formula for determining the proper quantity; just keep mixing powder into the clay until the desired shade is reached. After a bit of experimentation, you'll have a feel for the right amount.

Working with embossing powders can be quite messy, so do your mixing away from your primary worksurface, and use the following method to contain the powder. Begin by forming a well in your conditioned clay. Carefully pour the powder into the well, then bring up the sides of the clay and seal them so the powder is now trapped inside. Roll this powder sac into a snake, fold it in half, then roll again into a snake. (I've found that rolling on the worksurface is better than rolling between my palms.) Repeat these steps as needed; if you need more powder, form the clay back into a well and begin again. When the clay is nearly integrated, knead to finish. Because the powder stiffens the clay, it's best to use these mixtures soon after making them.

Glitter can be blended into clay in the same way as embossing powder. Iridescent glitter mixed with translucent clay yields some very convincing opal effects. Pieces incorporating powder or glitter can be baked following normal curing directions, and then finished by sanding, painting, and/or buffing to complete the simulations.

Integrated into the clay mixture, embossing powders prove useful for a number of imitations, such as the green and red granite and the marble seen here.

Translucent Effects

A number of simulations utilize translucent effects, which are especially suited to opals. The sheer look imparts depth and increases the realism. Pebbling (see page 90) also enhances the illusion. Both types of opals presented here begin with translucent clay. For milky opals, confetti is mixed directly into the clay; iridescent opals employ glitter as a surface treatment.

MILKY OPAL

The milky opal requires iridescent confetti. Jimmy Jem's Party Ice confetti, found in the party aisle of most craft shops, is ideal for milky opals. The irregularly shaped confetti pieces produce a more realistic effect than the uniformly shaped large-flake glitters. Into 1/4 package of translucent clay, knead about 1/4 to 1/2 teaspoon of confetti. Roll it into a sheet 1/8- to 1/4-inch thick, then remove any protruding confetti and smooth the surface with your fingertips. Cure the sheet in a preheated 275°F oven for 15 minutes. Let the sheet cool, then cut into the desired shape with a sharp knife or blade and gently sand the edges. Construct a setting for the opal (see pages 38–39), then return to the oven and cure for another 30 minutes.

IRIDESCENT OPAL

For the second type of opal, the most finely granulated iridescent glitter will produce the most realistic effect. I recommend Gick Ultrafine Glitter, labeled "The Original Prisma Glitter." This opal was made with translucent Sculpey III, aqua Sculpey III, and Gick Ultrafine Gold Glitter (other colors of glitter, such as pastel or blue, can also be used). You'll also need a resealable plastic bag, a roller or pasta machine, 400- and 600-grit wet/dry sandpaper, and a cotton cloth or bench grinder with a muslin wheel.

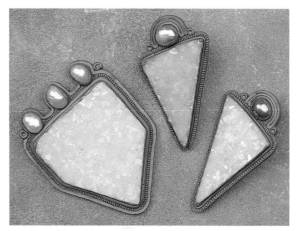

Craft confetti adds sparkle to simulated milky opals. The polymer clay settings of these pieces incorporate real pearls, which beautifully complement the opal imitations.

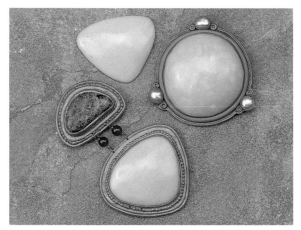

The iridescent opal employs finely granulated iridescent glitter, which is sandwiched between an interior clay form and a paper-thin layer of translucent clay.

1. Mix ¼ of a 2-ounce package of translucent with a ¼-inch-diameter ball of aqua. Pinch off the desired volume of clay for your imitation and roll into a ball. Pour some of the glitter into the plastic bag. (See Photo 1.)

2. Drop the ball of clay into the bag, seal it, and shake to completely coat the clay with glitter. Using a needle tool, remove the coated ball from the bag, roll it between your palms, and set it aside. Clean your hands thoroughly. (See Photo 2.)

3. Roll a sheet of translucent clay to paper thinness and wrap it over the glitter-coated ball. This step is somewhat tricky because the clay doesn't adhere readily to the glitter. Be patient and use a light touch. (See Photo 3.)

4. Pinch off and set aside the excess clay. Roll the ball lightly, piercing any air bubbles you might find. (See Photo 4.)

5. Place the ball best side up on a piece of paper. Flatten and smooth it to the desired shape. As you flatten it, the translucent layer will become thinner, revealing more of the glitter below. (See Photo 5.)

6. Place both clay and paper in a 275°F oven and bake either for 10 minutes if you intend to set and rebake the piece, or for 15 minutes per ¼-inch of thickness to finish it. To help prevent unwanted browning of the translucent clay, place a tent of foil over the piece.

7. If you want a glossy finish, sand the piece under running water, first with 400-grit and then with 600-grit wet/dry sandpaper. Buff with either a soft cotton cloth or an electric buffer fitted with a muslin wheel.

1

2

3

4

5

Imitative Striping

Malachite, agate, and ivory effects and stones that feature definite striations can all be achieved through the use of imitative striping. All of them begin with a log of the base color, which is the predominant color of the material being imitated. The step-by-step instructions given for malachite can be adapted to make agate or bone by working with the appropriate colors.

MALACHITE

Malachite's base color is medium green. Sometimes the distribution of colors through the log looks too even, so you may have to experiment to determine what works best. The technique requires bright green, black, and white (2-ounce packages or less); a roller or pasta machine; 400- and 600-grit wet/dry sandpaper; and a sheet of paper.

1. Condition half a package of bright green, roll into a 2-inch by $^3/_4$-inch log, and set aside.

2. Roll $^1/_{32}$-inch-thick sheets of black, white, and the remainder of the bright green. Cut pieces from each sheet with a $^1/_2$-inch-diameter cutter (the exact shape doesn't matter). Create four shades of darker green by mixing 1 part green with 4 parts black; 2 parts green with 3 parts black; 2 parts green with 2 parts black; and 4 parts green with 1 part black. Blend two lighter greens by mixing 2 parts green with $^1/_4$ part white, and 3 parts green with 1 part white.

3. Roll each of these blended greens into thin snakes. Make most $^1/_{16}$ inch in diameter snakes and a few $^1/_8$ inch in diameter. Cut all the snakes in half. On the green log formed in step 1, randomly place two of each of the four darker green snakes, and two of the next-to-lightest green. Add only one of the lightest green snakes, for a total of eleven snakes. (See Photo 1.)

4. Roll until the snakes are integrated and the surface is smooth. Continue to roll the log, twisting the ends in opposite directions. As you twist and roll, stripes will begin to form. The more you twist the log, the more stripes will form. Keep rolling and twisting until the stripes are $^1/_{16}$ inch apart.

5. At this point, the stripes are very evenly spaced; to make the simulation more realistic, the striping pattern must be more closely spaced and more random. To accomplish this, fold the log in half, then in half again. (See Photo 2.) Roll the log to fuse the folded sections, twisting and rolling until you've achieved the desired effect of fine, closely spaced stripes. (See Photo 3.)

6. To compress the log to a length of 1 inch, place your hands on the log and roll it, moving your hands toward the center while applying gentle pressure. The log will get fatter as you compress it, and the stripes will get thinner and closer together. (See Photo 4.)

7. At this point, beads can be made by cutting ½-inch segments from the fat snake and rolling them. Or you can compress the snake even more to make a cabochon or a Pi; to do this, place your thumb on one end of the log and your middle finger on the other, then squeeze the two ends together. Roll into a ball to fuse and smooth, then place it on a piece on paper, good side up. Press the ball down, shaping and patting until you've formed a low, domed disc. Roll lightly over the surface with a roller to smooth. To form a Pi, see page 92.

8. A third option is to flatten the clay into a malachite sheet by rolling it through the pasta machine. Make sure the stripes are not going through the machine parallel to the rollers (which would widen them); they must be fed perpendicular to the rollers, thus elongating them. (See Photo 5.)

9. Use as desired, then bake to cure. For a glossy finish, sand and buff.

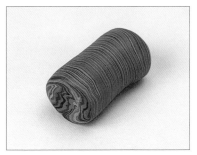

1

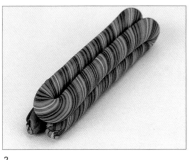

2

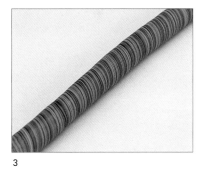

3

4

5

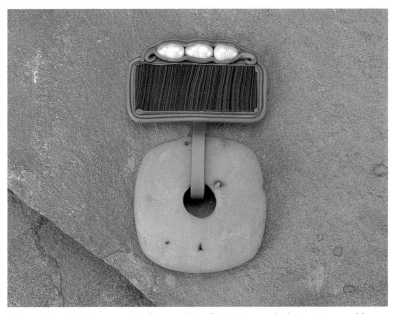

A faux stone Pi is suspended from a slab of imitation malachite set in a gold Promat surround and topped by three pearls.

IVORY

Simulated ivory also employs the same basic striping technique. The log that forms the base color is mostly composed of translucent clay; mix into it a ½-inch-diameter ball of white to minimize the pebbling effect. Arrange pure white snakes around the log, and then follow the instructions for malachite, beginning with step 4.

AGATE

Imitations of agate begin in much the same way as malachite, but instead of preserving the distinctive striped pattern, the clay is blended into a swirls. Begin with a translucent log base about 2 inches long and ⅜ inch in diameter. To this log, apply a brown snake and white snake, each ¹⁄₁₆ inch in diameter, and a gold snake and a mixed gold and translucent snake, each ⅛ inch in diameter. Roll to integrate the snakes into the log, twisting the ends in opposite directions as you roll to make candy-cane stripes. Keep on rolling and twisting until the stripes are ¹⁄₁₆ inch apart. Fold the snake in half, then in half again. Marble-mix the clay by folding from the outer edge toward the center about twelve times, stopping once it resembles the picture (below, center). Roll the clay through the pasta machine on the largest setting, or roll into a ⅛-inch-thick sheet with a roller. It is now ready to use for your chosen application.

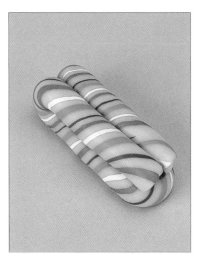

Agate simulations start out like the malachite log and are then marble-mixed. Experiment with different shades and proportions of brown and gold when preparing the snakes.

NONPAREIL MARBLED PAPER

The combed pattern often seen on certain marbled papers—such as on the endpapers of books—is known as "nonpareil." It can be simulated using a technique similar to the imitative stripping used for malachite. Begin with a log of the chosen base color (whatever color you want to be predominant); use about ¼ to ½ a package of clay. Add three contrasting colors to the log, either applied as separate snakes (as in the malachite and agate techniques) or as layered strips topped by a thin snake (as seen in the photograph, below, left). Roll until the surface is smooth, integrating the colors into a swirl. Continue to roll, twisting the ends in opposite directions. Fold in half twice, then roll and twist again. Form the clay into a slab about ⅜ inch thick, roll the surface with a brayer, then drag the teeth of a hair pick lightly across the surface of the clay, perpendicular—not parallel—to the stipes. Roll through the pasta machine or thin the slab with a roller, then use in chosen application.

The look of marbled paper is easily achieved with the imitative stripe method and is a great way to use up cane ends and other leftover color mixtures. For a feather-type pattern, drag the teeth of the hair pick down the clay, perpendicular to the stripes, then comb up between the first set of drag marks. The technique looks particularly appropriate on flat surfaces such as picture frames.

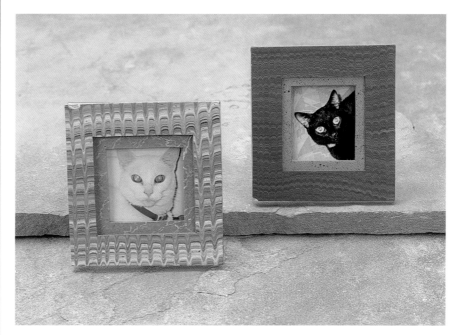

Metal Effects

PATINA

To simulate the appearance of oxidized copper, prepare a mint color by mixing white Sculpey III and a bit of green Sculpey III, then roll it to paper thinness (#6 or 7 on the pasta machine). Roll a sheet of gold or copper Promat to a thickness of 1/8 inch (#1 setting on the pasta machine). Place the mint sheet over the gold or copper sheet and roll the assembled clay down to paper thinness. Cut or tear the sheet and use it to cover an object, such as a bead, a picture frame, or a vessel. If using this technique for beads, cover a round base bead first, roll until the surface is smooth, then shape as desired. The act of rolling and reshaping the ball thins the clay further, enhancing the illusion.

MOKUME GANE

Mokume gane (pronounced moh•KU•may GA•nay) is an ancient Asian metalworking technique in which contrasting sheets of colored metal are layered, then strata are selectively cut away to reveal lovely, fluid patterns in rings and other shapes. The technique works beautifully with polymer clay, and was first adapted to this medium by Nan Roche and described in her book *The New Clay*. There are several methods to expose the ringed patterns within the layered slabs of clay. They all begin with a multicolored slab of clay, from which thin slices will be shaved off with a sharp blade. Artist Lindly Haunani places balls of clay beneath her layered assembly to push the layers up, then she slices away the raised clay to create the rings. By contrast, Tory Hughes pushes down into the slab (rather than building up from beneath), then slices across the indention to create patterns that are similar yet different.

To evoke the look of oxidized metal, sheets of patina-blend clay were used to cover base beads, which were then rolled to smooth the surface and shaped as desired. The patina finish also works very well on home decor items.

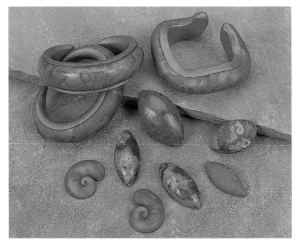

Based on a traditional metalworking process, mokume gane actually means "wood-grain metal." The mokume gane jewelry items seen here were given different finishes—some were sanded and buffed, others were not.

To create the colored slab for my mokume gane pieces, I utilize both conventional layering techniques and my own marble-mixing technique (see page 94). Rather than pushing the clay up or down, I drape the thinned slab over a convex form (such as a cured bead or other polymer clay form, or an inverted bowl) and shave thin slices off the top with a tissue slicer, often linking the revealed rings at certain points for a more intricate design. When I achieve a pleasing pattern, I smooth the surface gently and roll it lightly with a roller. I then place the sheet over a preshaped cabochon, a base bead, or other form and trim as necessary.

When choosing colors for this technique, experimentation is the best teacher. Start with colors that you think will mix pleasingly. There should be good contrast; layering a dark blue, a dark green, and a brown, for example, will not yield a visible pattern when sliced. Colors can also be dictated by the intended use, such as to create variations on certain imitations like agate or malachite. To further refine the agate simulation, divide the mixed clay (see page 100) into four equal pieces and stack one on top of another. Thin the stacked piece to $3/16$ inch. Place this prepared sheet over a convex form and cut away thin slices, then roll the surface smooth.

Mokume gane malachite utilizes the conventional stacking method to create the colored slab. Sandwich a $1/8$-inch sheet of loosely mixed bright green and white clay between paper-thin sheets of black (on the bottom) and medium green. Roll the assembly to $1/8$-inch thickness, cut into six equal pieces, and stack them, maintaining the same color sequence. Thin the assembled slab to $3/16$ inch. Place over a convex form, slice off thin layers, and smooth the surface.

There are several ways to combine colors for mokume gane. Begin with a brightly colored cane, or a small mass of clay surrounded by various colors pressed around the edge. Marble-mix by bringing the outer edges in toward the center, about a dozen times. Roll out a thin sheet, cut it into smaller pieces, and stack them. Flatten the stack, place it over a convex form, and shave off thin slices with a sharp blade.

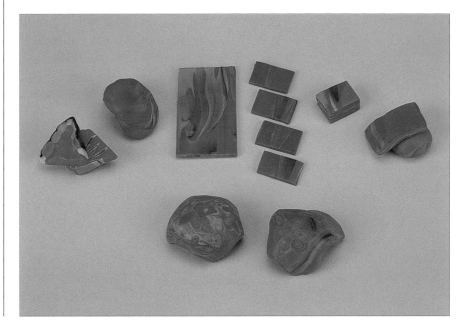

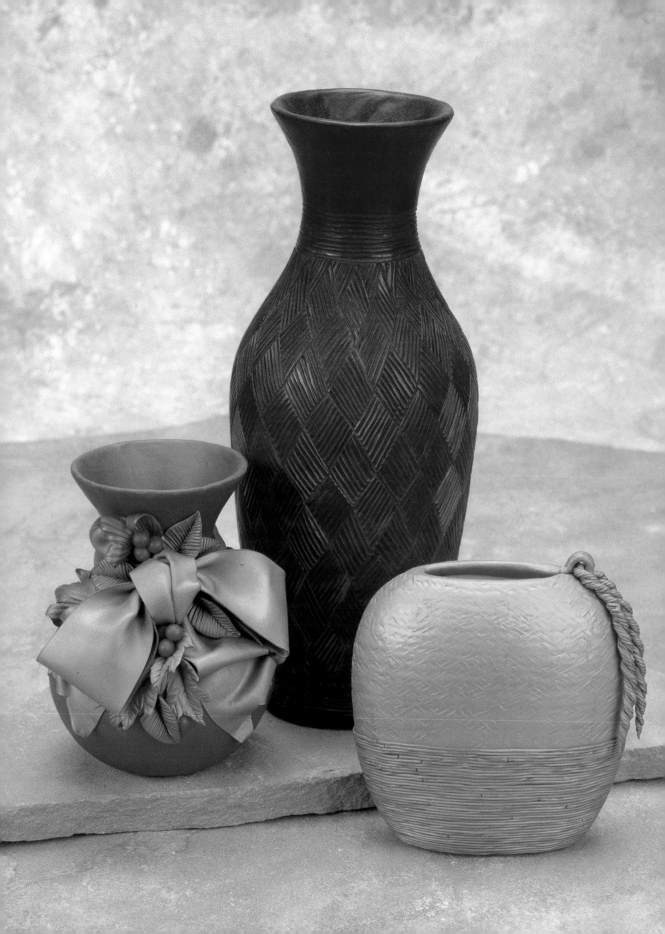

6 | **Vessels**

(Opposite) Three vessels made by covering existing forms with polymer clay illustrate the decorative potential of this application. The gold bow on the reddish vase was made entirely of Promat. (Above) Adorned with the baroque technique, a polymer clay vessel gives the appearance of terra-cotta.

Ceramic and glass vessels and many wood forms can easily be covered with polymer clay, and the low temperatures required for curing won't damage these materials. The technique is a wonderful way to conceal unattractive vessels or to enhance inexpensive ones. In addition to covering existing forms, it is also possible to make vessels entirely of polymer clay, through several different methods. And vessels lend themselves beautifully to many surface treatments and decorative accents, including texturing, carving, and inlaid mosaic patterns.

Covering a Vessel with Clay

The sheets of clay used for covering an existing form must be uniform, and need not be thicker than $1/16$ inch. A roller or brayer can be used to achieve this, but it's most practical to use a pasta machine. Once the piece is cured, some artists break the glass or ceramic base out of the piece (in which case the sheet of clay used to cover the vessel must be at least $1/4$-inch thick), but I have found that base forms provide additional stability and increase the usefulness of the covered vessel. A functional piece such as a vase that will be used to hold water will benefit particularly from having an interior form, to ensure a completely leak-proof vessel. In addition to covering glass and ceramic forms, you can also cover wood objects, boxes made of heavy paper—

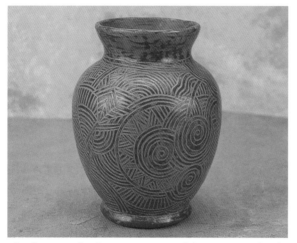

The design on the "lacquerware" vessel (a vase covered with a thin layer of clay) was scored on the surface, then carved after curing. Clay was pressed into the carving, the piece was cured again, then sanded and buffed.

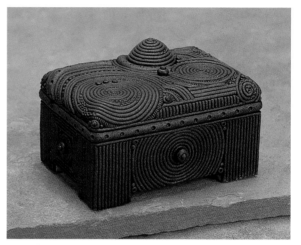

An ordinary box becomes a dramatic statement with the Balinese filigree technique. Rather than the random pattern seen on the beads in chapter 3, this design was dictated by the base form.

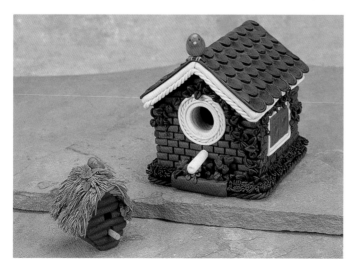

A clay-covered wooden birdhouse makes a charming project. Given the absorbency of the wood, it is wise to use a clay that will withstand expansion and contraction. Promat is extremely strong and makes a good base layer. Sculpey III is too brittle but can be used as detailing over the Promat layer. Create architectural elements with the clay gun. Use the slot or square discs for bricks and siding, the triangle and semicircle discs for window and door details, the lobed discs for rope edging, and the hair discs for roof thatching. For shingles, cut rounds from rolled sheets and place them on the roof beginning with the bottom row. Offset the next row, align the third row with the first, and so on.

anything that will withstand the curing temperature and that doesn't contain any flammable elements, such as certain glues. Certain materials—including wood, paper, and plaster—do not readily accept the clay and must therefore be prepared beforehand. If using one of these materials, cover its surface with an ovenproof paint (such as Deco-Art ultragloss enamel) or Sobo glue and allow it to dry before applying the clay. As with all other polymer clay applications, none of these projects should be used with food.

To cover a chosen base, drape a sheet of clay over it, smoothing and cutting where necessary, and forming butt joints to ensure a layer of uniform thickness. Begin with the bottom first, slowly working your way toward the top. Invert the item and press the clay onto the base and, when necessary, cut away the excess with a sharp blade. With your fingertips, smooth the seams lightly until they are no longer visible. Pierce any air bubbles with a sharp needle, then push to smooth them out. Once you have covered the vessel halfway up the sides, flip the piece over and work toward the top.

Although raw clay does stick to glass or ceramic, once cured it will not adhere. Be sure that the base is covered in such a way that it is secured beneath the clay. For example, the clay covering a straight-sided vessel should extend over the top of the lip to cover a portion of the interior, thus trapping the vessel inside. If the vessel has a flared lip, bring the clay up and over the top, covering the lip completely. When covering a rounded form, the primary challenge is to avoid distorting the areas that have already been covered; such distortion is often caused by holding the vessel while working on another section, thus softening the clay by warming it with the heat of your hands. For this reason, try to hold the piece as little as possible. Place the vessel on a piece of paper (or an index card) and rotate the paper rather than the item. The paper will eliminate the need to touch the vessel as you move and turn it.

After the vessel is completely covered, roll it lightly between your palms to smooth out the surface. You may then embellish it as you wish, either by adding decorative three-dimensional accents or millefiori slices (see page 57) before curing, or by carving, painting, and/or "glazing" with diluted clay afterward.

CREATING A TEXTURED VESSEL

Countless items can be used to impress designs into clay, creating an irregular or an all-over pattern. The vessel on the following page employs a carved polymer clay bracelet, rolled over the surface to impart textural interest. You can also make a texture ball by detailing a ball of scrap clay with a ball stylus, a fine needle tool, or the edge of a cutter. When you want to reproduce the pattern, simply press the texture ball onto the surface of the item. The technique can even be used for transferring patterns like fur or feathers. (The same principle is used on page 139 to texture the coral in the seahorse sculpture.)

The base for this project was a 4½-inch-tall flat-sided vessel, which was covered with gold Promat, textured with a carved bracelet, and adorned with strands extruded from a clay gun fitted with a medium-size spaghetti disc.

1. Cover a vessel with a ¹⁄₁₆-inch-thick sheet of clay, cutting to fit as needed and smoothing out all seams, puckers, and air bubbles. (See Photo 1.)
2. Roll your selected texturing device over the covered vessel. (See Photo 2.)
3. Load the clay gun and extrude strands long enough to reach halfway around the vessel. Separate the strands and place five strands side by side along each side of the vessel, beginning at the top opening. Pat lightly to ensure the strands adhere to the surface. (See Photo 3.)
4. For the decorative handles, roll a narrow strip of clay ¹⁄₈-inch thick. Place five strands of clay side by side on the strip, then trim away the excess strip along both sides of the strands, using a sharp blade. Cut two 1½-inch lengths of this prepared strip. Bend up the center of each to form a handle loop. (See Photo 4.)
5. Place a handle on each side of the vessel over the strands placed in step 3. Roll two ¼-inch-diameter balls of clay and cut them in half. Coil a strand over each half ball and place on the handles as shown. (See Photo 5.)
6. Bake in a preheated 275°F oven for 30 minutes. Remove and let cool.

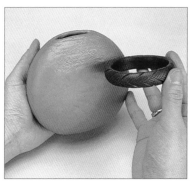

1

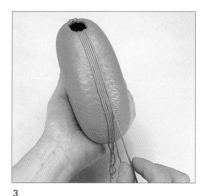

2

3

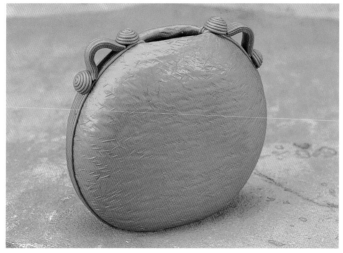

4

5

"Weaving" a Vessel

The illusion of a vessel that is woven entirely of polymer clay is actually accomplished by careful placement of snakes and strips of clay. Arranged over a base vessel, the clay elements appear to form an intricately woven pattern. In addition to the clay and base vessel, this project requires a pasta machine or roller, a hair pick, a sharp blade, and a knife-shaped sculpting tool or other implement to press down the edges of the strips.

The soft speckling of the Granitex on this woven vessel complements the delicate spray of flowers. After the weaving process was completed, ¹/₁₆-inch-thick snakes were arranged on the vessel in a trailing pattern, creating a line to follow for placement of the flowers and leaves. The nest was made with brown Granitex extruded from the clay gun.

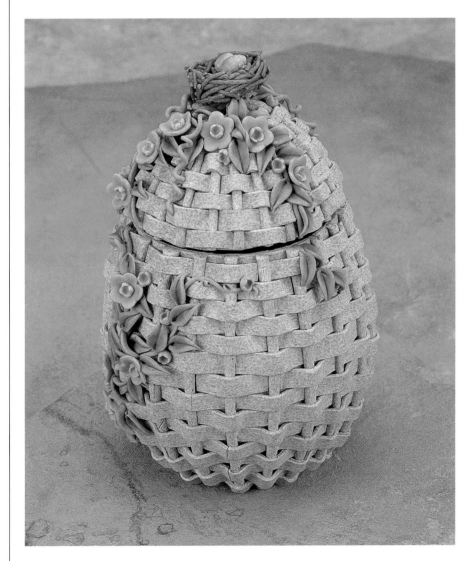

1. With the pasta machine or roller, roll out conditioned clay to a sheet $1/16$-inch thick. Cover the vessel with the sheet, as explained on page 107.
2. Roll snakes $1/16$ inch in diameter. Place them on the vessel vertically, spacing them approximately 1 inch apart. Make sure you have an even number of verticals. (See Photo 1.)
3. Roll another sheet $1/16$-inch thick. Position the hair pick at one of the shorter sides, lightly resting the tines on the clay. Drag the pick across the clay in a straight line, applying even pressure. Cut along the tine marks with a sharp blade to produce long strips of clay.
4. Weaving is done in rows, beginning at the top of the vessel. Place one of the cut strips all around the opening, pressing down gently between each vertical spine. Using a sharp blade, cut the strip along each side of one spine, removing the thin slice of clay that covers that spine. Skip one spine and repeat the cutting procedure on the following spine. This creates the illusion that the strip is emerging from below one spine, crossing over another and then threading below the next. Repeat until the first row is complete. (See Photo 2.)
5. The second row is worked in the same fashion, except that the spines exposed in the first row will be left covered this time, and those left covered before will now be exposed. Proceed around the vessel, cutting away the strip from alternate spines. To produce a crisp look, use a sculpting blade to press down the cut edges of the strip next to the spine. (See Photo 3.)
6. Alternate steps 4 and 5 until the entire vessel is covered. Add other clay adornments, if desired. Cure in a preheated 275°F oven for 30 minutes. (See Photo 4.)

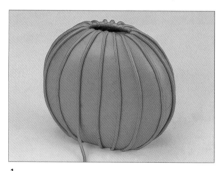

1

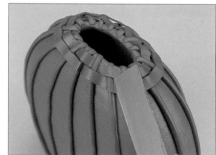

2

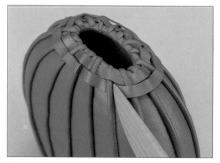

3

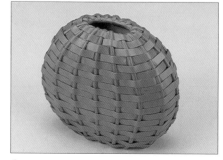

4

Making an Unlined Vessel

There are several methods for creating an unlined vessel consisting entirely of polymer clay. The clay can be molded over a glass, ceramic, stone, metal, or wooden bowl, or a form that has been shaped from foil. Shallow polymer clay bowls can be made by draping sheets of clay over a form (such as an inverted glass bowl) that is removed after curing. More rounded forms can be produced by forming and curing the upper and lower halves separately, bonding them together, then covering with more clay and curing again. A third approach is the balloon method, whereby an air-filled clay balloon is formed with your fingers, shaped using the resistance of air within. Once the desired shape is achieved, the opening is cut and refined.

A vessel whose midsection is larger than its top and bottom is made by shaping and curing each half (upper and lower) separately, then joining the cured halves. Coat the base form with a releasing agent such as Armor All (see page 80 for more about releasing agents). Cover the form with a sheet of clay about ⅛-inch thick. Be sure the form is covered in such a way that it can be removed. (In other words, don't shape the clay over a top edge or curve that would prevent removal.) Cure the piece following manufacturer's directions, allow it to cool, and remove the form. Repeat the procedure to form the top of the vessel, but this time cut a top opening before curing. When the two halves are complete, join them together with a few drops of cyanocrylate (super glue). Cover the joined halves (now a single vessel) with a ⅛-inch-thick sheet of clay. Add decorative details, if desired, then cure the piece again. After curing, the piece can be accented with carving, glaze, or another finish.

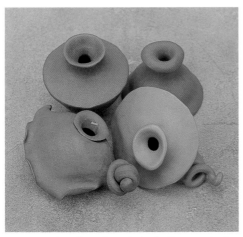

Four vessels, all made with the balloon method, demonstrate the unique shapes that this process makes possible. It also enables the creation of vessels with very small openings.

The green vessel was shaped in two separate halves over a rice bowl. The tan vessel derives its color from metal leaf beneath a paper-thin layer of translucent clay. The ornate box was formed with the slab method, whereby the sides and bottom were cut to size from clay slabs, cured, and joined with super glue. A thin layer of clay was then placed over the whole assembly, which was cured again.

Very irregularly shaped vessels can be made using foil as an armature. Compress aluminum foil into the desired vessel shape, then press the bottom side of the shaped foil form against your worksurface to flatten it. Cover the form (but *not* the flat bottom) with a sheet of clay $1/8$-inch thick, then cure completely following manufacturer's directions. After the clay has cooled, remove the foil form. It will not come out cleanly in one piece; you'll have to use a hooked sculpting tool or crochet hook to pull the foil out. Once the foil has been removed, place the cured item on a $1/4$-inch-thick sheet of clay, which will form the flat bottom of the vessel. Smooth the vessel to the sheet with your fingers, then cover the cured portion with a sheet of clay of $1/8$-inch thick (the entire vessel is now $1/4$-inch thick). Detail as desired, then cure again.

THE BALLOON METHOD

Small vessels of irregular shape are easily made using the balloon method. Essentially, an air-filled polymer clay balloon is formed. Shaping is easily achieved using the resistance provided by trapped air within. In addition to the clay, the only equipment needed is a sharp blade.

1. Roll a mass of clay into a ball. Press your thumbs into the clay to form a well. (See Photo 1.)
2. Gradually thin the sides of the mass between your fingers, forming straight walls. (See Photo 2.)
3. Cup the mass between your palms and apply pressure with your thumbs to bring the top edges toward each other, thus reducing the size of the opening. (See Photo 3.)
4. Continue reducing the opening, smoothing the clay with your thumbs. As you proceed, excess clay will be pushed up in the center, forming a protrusion. (See Photo 4.)
5. Once the balloon is formed, roll it lightly between your palms, then refine the shape as desired. (See Photo 5.)
6. Using a sharp blade, slice off the upper portion to form an opening. (See Photo 6.)
7. Smooth the cut edges and continue to refine the form. (See Photo 7.)
8. Decorate the vessel as desired. This example was brushed with diluted clay (produced by mixing it with Sculpey Liquid Diluent), which acts as a glaze. Cure the vessel according to manufacturer's directions. (See Photo 8.)

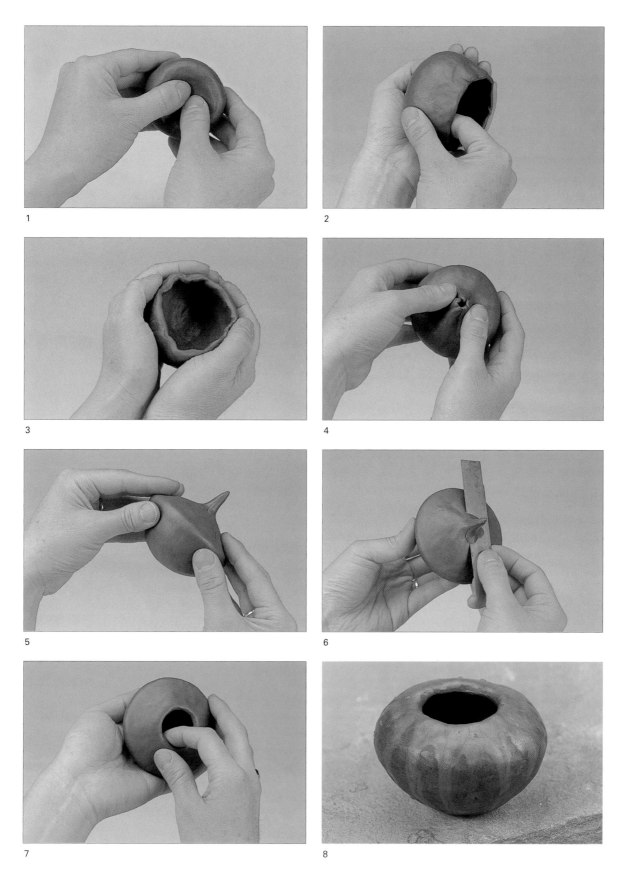

1

2

3

4

5

6

7

8

Creating a Mosaic Bowl

Polymer clay can be utilized to create mosaic effects, which can be used to decorate a variety of items, including brooches and pendants, and home decor items such as picture frames. The technique lends itself especially well to vessels.

The bowl pictured was formed over a stainless steel egg poaching cup, but any shallow metal, glass, or ceramic bowl can be used. The clay will stick to the form as you work; it does not need to be specially adhered. The mosaic "tiles" are produced by cutting $1/16$- or $1/8$-inch-thick sheets of clay into various shapes. For this project I used three sheets composed of polymer clay imitations: simulated malachite (see pages 98–99), blue-and-gold mokume gane (see page 103), and ivory (see page 100), with gold Sculpey III for the "grout" and the outer shell of the vessel. When placing the mosaic shapes over the form, remember to arrange them with the best side *down,* since that side will be the one visible when the vessel is removed from the base form. Also keep in mind that each shape should be surrounded by a small space, where the "grout" will eventually be applied.

1. Prepare the sheets in the colors and/or imitative techniques desired. Begin cutting them into various shapes and arranging them on the inverted base form. For the central bottom of this mosaic bowl, I cut a circle of clay with a round cutter, placed it on the base, then cut it into individual "tiles" and separated them slightly. (See Photo 1.)

2. Continue cutting and arranging the mosaic shapes until the base form is completely covered. (See Photo 2.)

3. To secure the tiles in place, roll a sheet of clay $1/8$-inch thick. (Note: This sheet forms an intermediate shell between the tiles and outer layer; it will not be visible in the finished piece.) Apply the sheet over the mosaic and press to adhere, cutting away excess and smoothing any seams as needed. Work carefully to avoid jostling the tiles beneath the sheet. Cure the assembly (vessel and base form together) according to manufacturer's directions. (See Photo 3.)

4. After the piece cools, gently remove the vessel from the base. For the "grout," add a few drops of Liquid Diluent to a chosen color of clay, then press this clay into all the spaces between the tiles. (See Photo 4.)

5. Remove excess grout by wiping the surface with a paper towel saturated with Liquid Diluent or with baby oil. (See Photo 5.)

6. For the outer layer of the vessel, roll a sheet of clay $1/8$-inch thick. Cover the outside with this sheet, then bake again to cure the grout and the outer layer. (See Photo 6.)

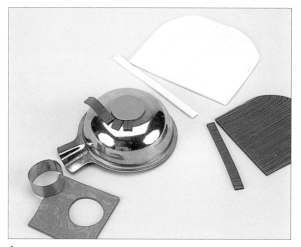

1

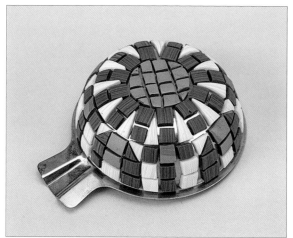

2

3

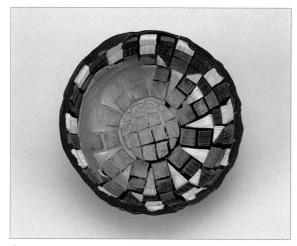

4

5

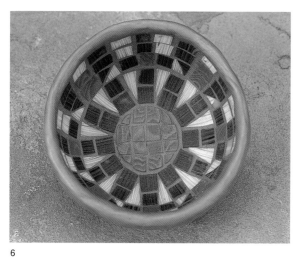

6

Making a Box

Polymer clay boxes are fairly easy to make. A simple, straight-sided round or oval box begins with a long rectangle cut from a sheet of clay at least ¹/₄-inch thick. (Sheets with a thickness of ¹/₈ inch can be used for small boxes—less than 3 inches across—or for those whose walls are no higher than an inch or so.) This rectangle will form the sides of the box, so its size will determine the size of the box; the longer it is, the larger the area of the box, the wider it is, the higher the box walls will be. Once the two short sides of the rectangle are seamed together, the circle thus created can be formed into a more irregular shape. The kidney-shaped box in the following demonstration was made from gold Promat; you will also need about 2 feet of medium-gauge craft wire, a pair of needle-nosed pliers, a wire cutter, and a sharp blade or a needle tool. A clay gun will make for easy formation of the decorative edging, but it can also be shaped by hand. Note that a large mokume gane bead was used for the handle (step 7); since the handle must be fully cured before attaching it to the lid, you may wish to prepare the bead ahead of time.

1. From a ¹/₄-inch-thick sheet of clay, cut a rectangle about 3 inches wide by 12 inches long to form the box wall. Bring the two short ends together and smooth the seam. Cut a piece of wire about 1¹/₂ inches long, bend it into a staple shape, and insert it in the clay, straddling the seam. Make about 8–12 more of these "staples" and set aside. (See Photo 1.)

1

2

2. Place the joined circle of clay on a $1/8$-inch-thick sheet of clay, which will become the base. Form the circular wall into the shape desired for the finished box. For the decorative edging, extrude about 14 inches of clay from a clay gun fitted with the triangular disk (or roll a snake by hand). Place the extruded clay around the circumference of the base and trim away the excess strand. Press the strand into the joint between the wall and the base. (See Photo 2.)

3. Using a sharp blade or a needle tool, cut out the base all around the decorative edging. Smooth the edging into the base layer. Turn the box upside down and insert the "staples" around the perimeter to strengthen the joint between the base and the walls. (See Photo 3.)

4. Place the stapled base on a $1/8$-inch-thick sheet of clay, cut around the edge, and smooth the two base layers together. The base will now be $1/4$-inch thick, with the staples hidden between the two layers. Cure in a preheated 275°F oven for 20 minutes.

5. To create the lid, invert the box (after it has cured and cooled) on a $1/8$-inch-thick sheet of clay. Create another strip of decorative edging, as in step 2, but press it only against the clay sheet, not against the box walls. (See Photo 4; note that this picture shows the box base with the staples still showing, before the second layer was added as in step 4.)

3

4

6. Cut out the lid all around the edging, then remove the box from the lid. Smooth the edging to the lid, using your fingers or a Clay Shaper.

7. To form the handle, cut a length of craft wire about 8 inches long. Wrap a very thin strip of clay around the wire as shown, leaving about an inch of wire exposed at one end. Place a decorative bead about $1^1/4$ inches long in the center of the wire, then wrap another strip of clay around the wire on the other side of the bead. Bend the wire at right angles to the bead on each side. Bake the handle to cure. (See Photo 5.)

8. Place the exposed tips of the handle against the lid to mark its placement. Using a needle tool, drill holes at the marked spots, but do not insert the handle yet. (See Photo 6.)

9. Place the lid on the box and bake in a preheated 275°F oven for 20 minutes. Once the piece has cooled, insert the handle through the lid holes. (See Photo 7.)

10. On the inside of the lid, twist the wire to secure the handle. (See Photo 8.)

11. To form the interior layer of the lid that will cover the handle wire, press the lid against a $1/8$-inch-thick sheet of clay. Cut out the shape and smooth it inside the lid.

12. Create a structure to protect the lid during final curing by cutting a hole in a piece of cardboard. Place the cardboard over an ovenproof object such as an aluminum can. (See Photo 9.)

13. Invert the lid into this structure, which will keep the handle from contact with any surface and prevent the lid from bowing during the baking process. Complete the curing in a preheated 275°F oven for 20 minutes.

14. On this finished piece, further adornment was added to the handle by placing two circles of clay on each arm of the handle. To utilize this detail, add the clay circles in step 9 when the handle is inserted into the lid.

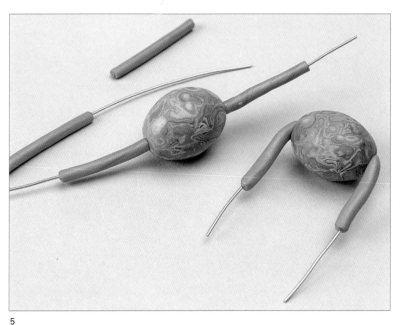

5

6

7

8

9

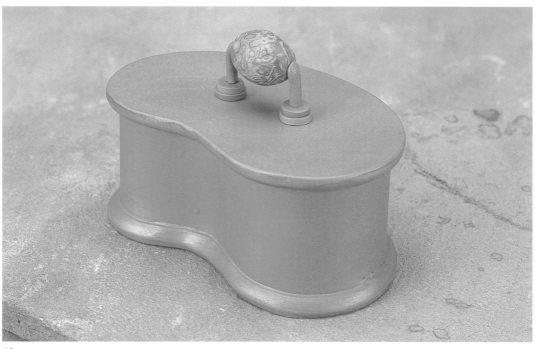

10

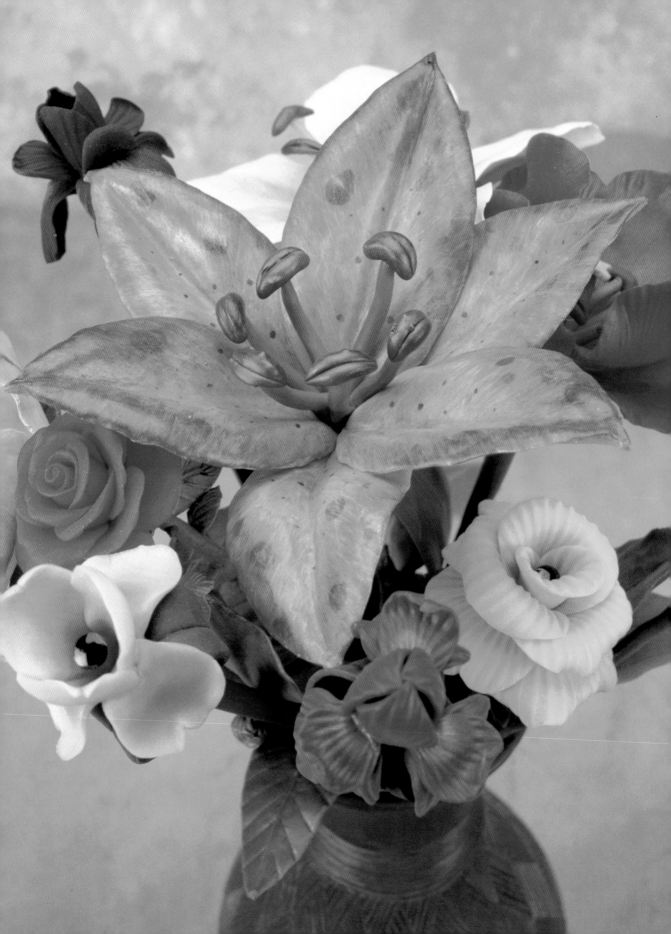

7 | Floral Forms

(Opposite) Lilies, poinsettias, poppies, tulips, and other long-stemmed flowers may require that each element be individually wired, for added support and to help very large petals retain their curves after curing. The petals of more compact flowers do not require this additional step. (Above) With its solitary petal and single, unveined leaf, the calla lily is the simplest of all flowers to make. The yellow spadix is textured by rolling the handle of the Pro Tool over the clay.

Florals have long enjoyed great popularity. The lovely ceramic pieces by Capodimonte are favored collectibles worldwide. And the aisles of any craft store abound with silk flowers of almost infinite variety, in varying degrees of realism. Polymer clay can be used to create remarkably realistic florals for use in a wide range of projects. With a few easy techniques and an understanding of the characteristics of polymer clay, you can create stunning flowers and leaves to utilize in articles of home decor and jewelry. Decorate a picture frame, a vase, napkin rings, or perhaps the base of a stemmed candlestick. If you prefer to make wearables, try attaching a few violets to a barrette finding, or make a simple rose or sunflower lapel pin. Or you may find satisfaction enough in the exercise of making these beautiful forms.

Tools and Preparation

I have a particular fondness for natural forms and have spent long hours in pursuit of realistic polymer representations of them. With some simple techniques, you'll find it possible to attain a level of arty realism with the polymer medium. If you can, invest in a good four-color flower and garden book. It will prove to be an invaluable reference for ideas about shape and color and will also help in achieving botanical accuracy.

Promat and Cernit are the strongest of the polymer clays, followed by Fimo and then Sculpey III. Because of their greater flexibility and strength, Promat, Cernit, and Fimo can be used for both wearables and home decor use, while Sculpey III is best used only for home decor, unless the wearable pieces are small. When constructing any wearables, remember that a sturdy, solid flower with thicker petals will better withstand wear than a more delicate form.

To simplify the entire flower-making process and help ensure uniform petal and leaf size, I use Kemper Enterprises' cutter sets, available at better craft stores. The rose cutter set is composed of five circles of various sizes. The leaf cutter set features four sizes of one leaf shape (a paisley form). Kemper also manufactures pattern cutters in teardrop, heart, square, and star shapes ranging in size from $3/16$ to $3/4$ inch. The tiny cutters are wonderful for miniature use and the larger cutters make nice medium to large flowers and leaves. Kemper's Pro Tool or another sharp needle tool is essential to produce the veining of petals and leaves. Most craft stores and many cooking and baking supply outlets also sell flower-shaped cookie cutters.

To use the cutters properly, your sheet of clay must be of even thickness. A pasta machine is highly recommended for this, but if you don't have one, with some practice a brayer will do as well. Generally, the larger the flower, the thicker the sheet. For medium-size flowers, I use a thickness of $1/8$ inch (the #1 setting on the pasta machine). The actual use of the cutters is quite simple: place your fingers on the cutter and press it into the clay, then depress the plunger to release the clay. Just remember not to depress the plunging mechanism before you want the clay to eject.

Clay-cutting utensils—such as the Kemper rose cutter seen here—enable more efficient flower production, by saving time and by ensuring uniform petal and leaf size.

Basic Construction

To counteract the sagging that can occur as polymer clay cures, some floral elements—such as upright petals—require either external assistance (a wad of foil or clay beneath an arching petal, or a wire between two layers of clay) or integral structural support (some thickness at the petal centers). Happily, these options will not badly affect the final product. As long as you leave the center area of petals and leaves thick, you can make the edges very thin to achieve a delicate appearance. Sagging is least pronounced in Sculpey III and Promat, so they generally only require support when petals or leaves are extremely thin, or when the finished flower will have a diameter larger than 5 or 6 inches. Cernit is most prone to sag, so all floral elements made of Cernit must have either thick central portions or some form of support.

There are several basic methods of constructing flowers. In the overlapping method (typified by roses and rununculus) the size of the flower increases as each succeeding petal is placed around a tight center bud. The flower is then trimmed at the base and given a calyx around the bottom. Depending on intended use, the entire flower can then be cured, be attached to the item being constructed and then cured, or be wired prior to curing and used in arrangements or wreaths.

More common is the base construction method (used for daisies and poinsettias, for example), whereby petals are arranged around the exposed center of a separate base and attached directly to that base. In this type, flower size is dictated by the length of the individual petals. Flowers made in this manner can be used the same way as those made with the overlapping method.

Certain more complex flowers require techniques that combine elements of the first two methods. The iris is constructed around a dowel or a chopstick (which serves as a base); the petals and leaves are then arranged around this core in a manner somewhat resembling the overlapping method.

When creating an arrangement, remember to vary flower size. Use buds as well as large, mature flowers. Study the composition of existing arrangements, then try applying those concepts and ideas to your own creations.

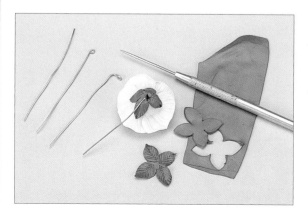

If you plan to use the flower on a wreath, in an arrangement, or for any other use that requires wire for a stem or a means of attachment, insert the wire before curing the flower.

OVERLAPPING METHOD

Roses and similar flowers are built around a tightly wound center. Cut three to five circles with the smallest cutter, five with the next size, five with the next, and so on. Form the circles into ovoid petal shapes, slightly thinning the edges. (If you're working with Cernit, be sure to leave the lower central portion somewhat thick.) Roll one of the smallest circles around itself, gently curving the top edge outward. Continue adding petals around this center, progressing from smaller to larger and gradually increasing the outward curve. Cut a pointed-clover shape for the calyx, add veining (see page 129), and attach to the underside of the flower. If desired, insert the loop of a long piece of wire into the base and bake flower and wire together.

BASE METHOD

Flowers whose petals radiate around a visible center are constructed on a base for better support. Place a small circle or star upon a slightly larger circle. Vein the petals (see page 129) and attach them around the edge of the upper circle. Add the desired center. Place veined leaves beneath the petals. Flowers made with this method are best suited to flat use. Attach them firmly to a home decor item such as a picture frame, for example; small, sturdy flowers can also be used for wearable pins.

Floral construction can follow several methods. The pink and yellow roses employ the overlapping technique, whereby petals are layered over a tightly wrapped center. The other two flowers are made with the base method, which utilizes a separate foundation to support the petals. All the flowers have been attached to square tube segments for use as napkin rings.

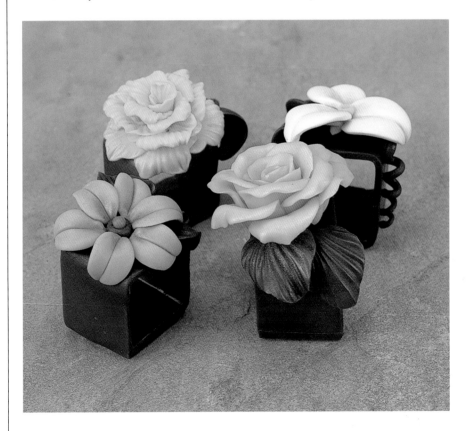

The base method of floral construction begins with a sturdy support, in this case a circle of clay topped by a flattened star. After the petals are formed, they are pressed onto the base, then a center motif is placed in the middle (here, a cane slice). Leaves are veined and added, if desired. Flowers made with the base technique should be used in applications where they will sit on a relatively flat surface, such as vases and other home decor items.

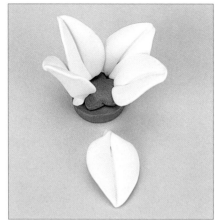
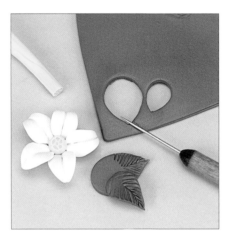
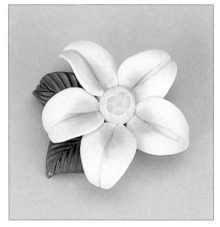
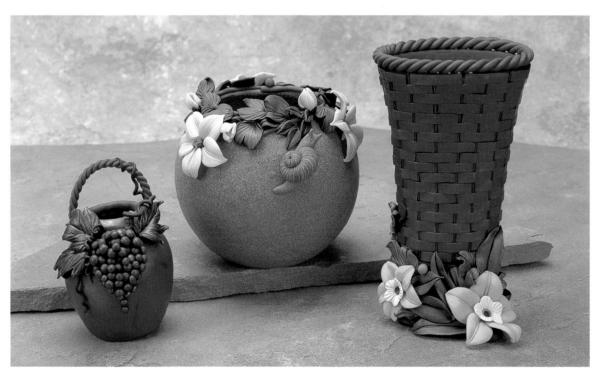

125

COMBINATION METHOD

The iris is somewhat unique. Because some petals droop while others rise above the flower's vertical center, construction utilizes aspects of both the overlapping and the base methods.

1. Cut three leaves, add veining (see page 129), and elongate them. (See Photo 1.)
2. Attach the prepared leaves around a slender dowel or stick about 1 inch from the top, shaping them as shown. (See Photo 2.)
3. Following the same technique as for the leaves, form three medium petals and three larger ones. (See Photo 3.)
4. Attach three medium petals around the exposed tip of the dowel, shaping and flaring the edges slightly. (See Photo 4.)
5. Arrange the other three medium petals around the point where the leaves and upper petals meet, curving them slightly outward and up at the tips. Place the three largest petals just below the ring of medium petals, curving them downward. (See Photo 5.)
6. Cover the dowel with clay to form the stem. If necessary, place small balls of petal-colored clay beneath the lower petals to prevent drooping. Accent and highlight the petals with blush or eyeshadow before curing. Daffodils can be created with a relatively similar construction process. (See Photo 6.)

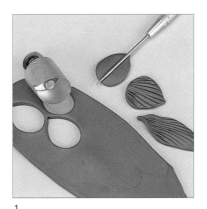

1

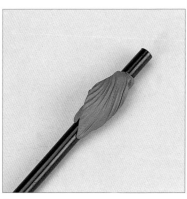

2

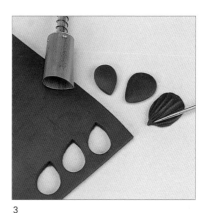

3

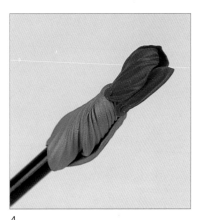

4

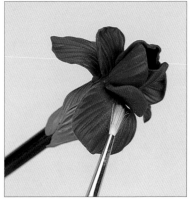

5

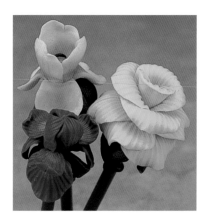

6

WIRED METHOD

Constructing long-stemmed flowers frequently entails individual wiring for each element, particularly if the flower has large, distinctly separate petals.

1. For a lily, begin by cutting six pieces of medium-gauge wire. Cover the upper half of each wire with translucent green clay, leaving the tip clear. Cut a copper-colored log into six equal pieces, form each into a kidney-bean shape, and press them onto the tips of the wire, adding a depression across each with the side of a needle tool. (See Photo 1.)

2. Gather all six stamens together, bend them away from the center, and compress the clay where they meet toward the bottom. (Promat stamens can also be shaped after curing.) Add a 10- to 12-inch piece of heavy wire and bind all the wires by wrapping repeatedly with a lightweight wire. Bake for 10 minutes following manufacturer's directions. (See Photo 2.)

3. Foil and wire provide internal strength. Cut six petal shapes out of foil. Place a foil petal on a sheet of clay $1/32$-inch thick, add a length of wire, then cut out the petal about $1/16$ to $1/8$ inch beyond the foil. (See Photo 3.)

4. Flip the petal construction over and repeat, then create five more petals in the same manner. (See Photo 4.)

5. To shape the petals, pinch the underside along the wire spine, then curve each half slightly outward. Bake for 10 minutes. (See Photo 5.)

6. Bind all the finished petals around the stamen grouping. (See Photo 6.)

7. Cover the exposed wires with clay to form the stem, bringing it up over the petal base slightly to create a calyx. Form the leaves following the petal process in step 3, then bake for 10 minutes. To complete the flower, bake the whole assembly for about 20 minutes. (See Photo 7.)

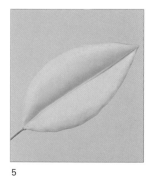

1

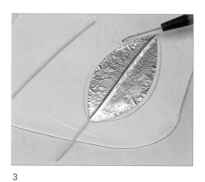

2

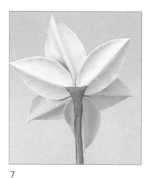

3

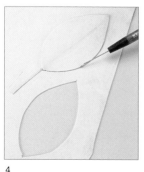

4

5

6

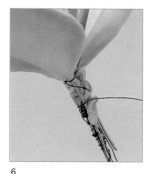

7

Leaves

Though flowers may take center stage, the importance of leaves must not be overlooked. Without leaves to provide a foundation, your flowers will look very lonely and the arrangement incomplete. Plan on using at least two leaves on any flower, preferably three and sometimes more. Leaves should vary in size and shape, and you may want to incorporate different shades of green or blue-green. Gold Promat adds a lovely warmth to any green base color. For a cooler effect, add silver Promat.

Kemper Enterprises' basic leaf cutting set offers a paisley shape in four sizes. Kemper's teardrop shape, ranging in size from 3/16 to 3/4 inch, also works well for leaves, as do many cookie cutters. Keep in mind that variety is important. Prepare the clay as for petals (see page 122) and cut shapes that approximate those found in nature for your chosen flower.

With compact flowers, especially those used in wearables, leaves can often be attached directly to the underside of the flower. For arrangements and home decor items, leaves generally should be wired separately. For each leaf, cut two identical clay shapes, sandwiching a wire between. If the leaves are large, add a layer of foil as well as the wire between the layers of clay.

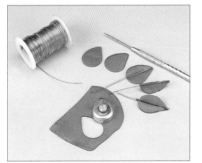

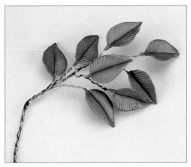

Between two identical leaf shapes, sandwich a wire, and a layer of foil if the leaves are large. Texture can be added with a variety of equipment, such as the side of a skewer.

A fine needle tool is an ideal veining implement; press the tool's side against the leaf to form veins, varying the pressure for more or less definition. You may find it easier to work with the item in your hand rather than on the worksurface.

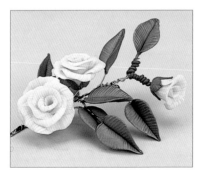

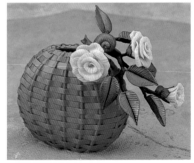

To create a full floral spray, twist the thin wires of individual, partially cured leaves over a sturdier wire base, then wire on partially cured flowers. Cover the wire branches with clay, complete the curing process, then use the spray in an arrangement, or attach it to a wreath or a home decor item. Note that the leaf edges were tinted with blush before curing.

Surface Design

Rather than using surface impressing molds, I prefer to detail my floral forms in several ways that allow for interesting variations and enable me to achieve an even greater degree of realism. By experimenting with color, texture, veining design, and overall shape and size, you can produce a tremendous variety of floral forms.

VARIEGATION

Variegated flowers are easily made by cutting petals from a sheet of prepared variegated clay. Follow the basic technique for marbled paper (see page 101), but omit the comb-dragging step. The effect is most successful when opaque and translucent clays are combined. When using petal cutters, remember to follow the "grain" of the variegated sheet.

VEINING

Using the Pro Tool or other fine needle tool, you can easily master the veining technique seen in many petals and almost all leaves. But instead of using the needle tip itself to score lines, you'll utilize the side to impress texture onto your leaves and petals by laying the side of the tool across the leaf or petal and applying medium pressure to form a "trench" in the surface. Begin by creating a fairly deep impression for the center vein, about halfway through the thickness of the clay. Close the impressed vein slightly and then detail the veins branching off it.

SURFACE TINTING

The final touch of realism for your wonderful flowers and leaves comes with the addition of powder tints. Fimo's metallic powders, called pulvers, are toxic and must be used with caution, although Pearlex Powders by Jacquard are fairly safe. Eyeshadows and blushes are a wonderful alternative; they are nontoxic, inexpensive, and readily available in a wide range of colors. (Remember: once you use makeup for your clay, don't use it again on your skin.) Select an accent color, load the brush, gently blow away the excess, and apply to uncured flowers and leaves. (Artist Terri Brock recommends that if you are adding very fine details or working in miniature, mix the powdered shadow with water and paint the details on.) Try adding a cranberry-red to the edges of your leaves, or perhaps a little gold to the center area. Though simple, this technique will add subtleties that will greatly enhance your finished piece. Experiment to discover which shadings you prefer.

8 | Figurines and Sculpture

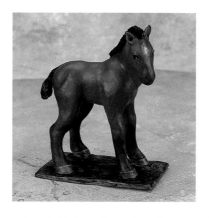

(Opposite) The realism of the Santa Claus bust was achieved by taking advantage of the translucence of Super Sculpey for the skin and by making extensive use of the clay gun, extruding and carefully placing long strands for the beard and shorter ones for the hat trim. (Above) The horse began as a foil-and-wire structure that was then covered with Sculpey III. Detailing was accomplished with the use of Colour Shapers and wooden tools.

Polymer clay is ideal for creating figurines, sculpture, and dolls. Because it is easy to work with and requires only an ordinary oven for curing, the medium readily lends itself to mass production of small items like "cute" figures, holiday ornaments, and refrigerator magnets. Often seen in gift stores, craft fairs, and miniatures shows, these little objects are generally fairly simple to make. But, by following a logical, step-by-step approach, even the novice polymer clay artist can learn to produce larger, more complex figures, sophisticated sculptures, and realistic dolls' faces.

Sculpture Basics

Among the most versatile sculpture tools for polymer clay are Kemper Enterprise's wide variety of wire loop tools set in wooden handles, and their pointed wooden tools for blending and detailing (see page 20). Forsline & Starr's rubber-tipped Colour Shapers and Clay Shapers tools, designed for use by painters and ceramicists, are also quite useful, but since they are new to the market they may be difficult to locate. Check the sculpture section of your local art supply store for a selection of traditional sculptors' tools that you can adapt to your polymer clay work. Another supply you may want to have on hand for sculptural work is Liquid Diluent, which serves as a terrific polymer "glue" when you want a strong clay-to-clay bond.

Of all the polymers available, Sculpey, Super Sculpey, Sculpey III, and Promat are perhaps the most appropriate for figural work since they feel and behave more like ceramic clays than like the polymers they are. They are "dead" clays; that is, since they do not "bounce back" or "fill in" after being shaped, they will retain fine tooling and detailing. They are also the easiest clays to blend and to smooth together, so these clays are used by a great many sculptors and doll artists, as well as for producing prototypes that will be used for casting in other mediums.

You may be able to use other types of polymer clay successfully in figural work, as long as you are familiar with the clays' individual characteristics. Cernit, for example, is extremely difficult to sculpt in an additive fashion. The pieces do not readily blend; they do stick together, but the resulting seam is difficult to remove. And because of its translucence, the clay must be absolutely clean or the soiled clay will show through when blending is attempted. Yet that very translucence is what makes Cernit a favored clay among doll artists, who use it as a "skin" over sculpted heads to add to the realism of their work. Many of my sculpted pieces begin as mixtures of "scrap" clay: leftover bits of Sculpey III, Promat, and Super Sculpey mixed together and later painted.

In addition to Sculpey III and Promat, artist Ginnie Neill uses Fimo and Cernit for her creations, often combining all four types in the same piece. A master of miniatures who has produced more than eight hundred variations of animals and human figures, Neill cures her pieces in a convection oven, which she asserts makes her work harder and stronger. The convection oven, however, tends to dry out the clay and make it less flexible, even brittle, so weigh these factors before you decide to invest in a convection oven for curing your clay. A conventional or toaster oven will generally prove quite adequate for curing your sculptural pieces.

Use fictional characters or historical people as inspiration to create a variety of basic faces. Their cartoonlike appearance is generally less intimidating to the novice clay artist than a more realistic sculpture or doll's head. Extrude strands from a clay gun or garlic press and experiment with lots of different hairstyles.

SIMPLE FACES

For the novice sculptor, caricatures are easier to achieve than lifelike faces. Though basic in construction, simple faces lend themselves to several uses, including ornaments, refrigerator magnets, or decoration around a picture frame or other flat surface. They are easily given distinct personalities by varying their hairstyles and feature placement. To form a simple face, roll a ball of clay and reshape it into an oval. Place the oval on your worksurface and flatten it with your fingers, leaving the clay thicker in the center and tapering it toward the edges, orienting the oval so that it is wider than it is tall. Feature placement is quite subjective; many of these faces draw their charm from small, closely spaced features, but it pays to experiment with different feature types and spacing. The ears are balls of clay placed on the face and then flattened with the round end of a paintbrush. The many different hairstyles all began as clay extruded through a clay gun; some was then braided, twisted into ropes, or curled around a tool handle or bamboo skewer.

SMALL FIGURINES

Small figurines are one of the most popular of all projects produced with polymer clay. They can be as simple as three white balls, graduated in size, placed together to form a simple snowman, with tiny balls of clay for the eyes and mouth and an orange cone for the nose. Most figurines are really only a bit more complicated than that. By mentally dividing the figure into its most basic forms—triangles, circles, ovals, oblongs, and so on—its structure will become clearer. Form each part separately, then assemble the pieces. For the easiest approach, begin with a seated figure, the simplest type to make. The chimpanzee figure group shown in chapter 1 (page 33) was assembled from a set of basic shapes in varying sizes: balls for the head and muzzle; teardrops for the body, arms, legs, hands, and feet; and flattened ovals for the eyes and ears. To give a furry appearance, a mixture of black Granitex and black Sculpey III was used.

To produce somewhat more realistic figures, try to work from a picture or a live model. Once again, reduce the figure to its simplest geometric elements and then apply what you deduce by making the appropriate shapes and assembling the pieces to form the whole.

Miniature items do not generally need internal armatures, though for additional strength you may want to insert toothpicks or small pieces of wire to connect adjacent pieces. The simple Santa and reindeer were constructed by assembling a series of very basic shapes.

Netsukes are traditional Japanese carved ivory pieces attached to the "obi," or sash. These imitations are all made of Sculpey III. Like the little bird sculpture on page 74, the chicken and rabbit were textured with a needle tool and painted.

Harvest Candlesticks

A luscious autumn harvest clustered at the base of a pair of candlesticks makes an attractive holiday centerpiece. Though the finished product appears elaborate, the individual leaves and vegetables are fairly simple to make. If you're interested in creating more advanced sculptures but feel intimidated by figures, try honing your skills by making these organic forms.

1. Roll a sheet of conditioned terra-cotta-colored clay to $1/16$-inch thickness. Place the candlestick on the sheet and cut out the clay, $1/4$ inch larger than the base all around. Using a cutter the same diameter as the candlestick stem, remove a circle from the center. With a sharp blade, cut from the center hole to the outer edge. Place the disk around the base. Cut away any excess where the edges overlap, then smooth the joint. Wrap the outer edges around to the underside of the base. (See Photo 1.)

2. *Peas.* Mix green clay with some gold clay. Roll a snake to the desired diameter of the peas. Cut into segments of the same length as the snake's diameter and roll each into a ball (each pea pod requires four or five balls). Roll a sheet of the same clay to $1/32$-inch thickness. Place the peas on the sheet and cut around them. Bring the clay up around the sides of the peas, then pinch and curl the ends slightly. (See Photo 2.)

3. *Pumpkin.* Mix orange clay with some gold. Roll a $1/2$- to $3/4$-inch ball. Make a deep indentation in the ball with the blunt end of a paintbrush. Using the edge (not the tip) of a needle tool, impress lines around the ball, running from the indentation to the bottom. Roll a small greenish-gold teardrop and insert into the indentation for the stem. (See Photo 3.)

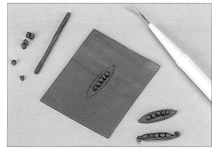

1

2

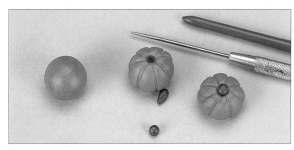

3

4. *Eggplant.* Mix purple clay with some gold. Roll a ball $1/2$ to $3/4$ inch in diameter, then work it into a teardrop shape. With the blunt end of the brush, make a deep indentation in the small end of the teardrop. From a $1/32$-inch sheet of greenish-gold clay, cut a star shape and two leaves. Place the star over the indentation, pressing its center into the hole. Using the edge of the needle tool, impress veins in the leaves. Pinch the bottom of the leaves together and insert in the hole. (See Photo 4.)

5. *Apple.* Mix red clay with some gold. Roll a $3/8$-inch diameter ball, then work it into a slight teardrop. Flatten the pointier end and make a deep indentation in the larger part with the paintbrush. Cut a leaf from a $1/32$-inch sheet of greenish-gold clay and impress veins with the needle tool. Roll a small brown stem. Place one end of the leaf in the indentation then press the stem into the hole. (See Photo 5.)

6. *Carrot.* Mix orange clay with a small bit of gold. Roll a $5/16$-inch diameter ball, then place the ball on the worksurface and roll to form an elongated, tapering teardrop. Make an indentation in the wider end with the paintbrush. To texture the carrot, impress wrinkles by rolling it back and forth while exerting gentle pressure with the side of a needle tool. Cut longish leaf shapes from a $1/32$-inch sheet of greenish-gold clay and impress veins with the needle tool. Pinch the leaves together and insert in the hole. (See Photo 6.)

7. *Ear of corn.* Load a clay gun with gold clay and the medium-size hair screen and extrude 1-inch lengths. Roll a $1/2$-inch diameter ball and work into a long lozenge shape. Place one strand of extruded clay lengthwise on the lozenge. Using a dental tool, make a series of closely spaced impressions to suggest individual kernals. Place another strand next to the first. Impress and repeat until the lozenge is covered halfway around. From a $1/32$-inch sheet of gold clay, cut teardrop shapes, with either a shaped cutter or the tip of the needle tool. Elongate these until they are $1/8$ inch longer than the corn, then create surface texture with the needle tool. Overlap three around the undecorated half of the corn, making sure the impressed kernals are still visible. Make a deep indentation in the stem end of the corn with the paintbrush. Cut three triangles, pinch one corner of each, then pinch all three together and insert in the hole. (See Photo 7.)

8. *Leaves.* Cut leaves of various sizes and shapes from shades of green and brown clay rolled into $1/16$-inch sheets. Add veins with the side of the needle tool then curve leaves to add dimension. Tint the edges with eyeshadow, as described in chapter 7. (See Photos 8 and 9.)

9. Arrange the vegetables and apples over the base of the candlestick, filling the gaps with leaves as needed. (See photo 10.)

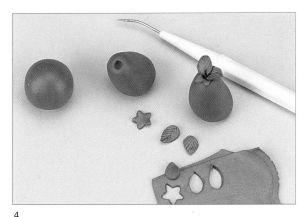

4

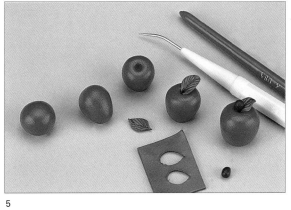

5

6

7

8

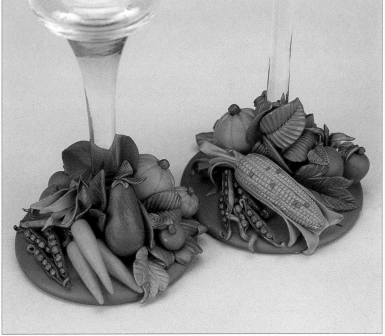

9

10

Larger Sculpture

Though internal reinforcement is not usually needed for small items, larger pieces require some sort of armature to add strength, thereby enabling items to retain their shape. In addition, because large masses of solid clay often develop cracks during the curing process, the bulk that an armature provides allows you to use thinner segments of clay over its structure. This not only saves clay; it also helps ensure walls of even thickness for better curing. Foil and wire make wonderful armatures, alone or in combination with each other. They will accept whatever shape you give them, are easily covered with clay, and there's no problem with baking them right inside the sculpture.

A larger piece that aims for greater realism can seem quite intimidating at first, but, as with simpler sculptures, try breaking the whole into its component shapes. Find a drawing or photograph of the subject you wish to sculpt; having a visual reference as you work will help greatly.

The seahorse sculpture began as a sheet of aluminum foil wadded into the general shape of the creature. This armature was then covered with Sculpey III (for demonstration purposes, tan clay was used, but translucent clay will yield a more realistic look). For ease of handling, the tail was left exposed to provide an area that could be held while working. Bits of clay were added and blended to the face to form the cheeks and horns. A large ball stylus opened the eye sockets, into which were inserted precooked white balls for eyes; dots of black clay were then added for the pupils. The basic body pattern was defined with a needle tool, then strands of clay (extruded from a clay gun) were placed over the impressions. The back fin was added and the seahorse was baked. Clay was then applied over the tail, which was detailed with a Colour Shaper. The piece was then baked again.

The base is a wooden plaque that was first brushed with a mixture of Liquid Diluent and clay to aid clay adhesion; painting with water-based enamel also works. Select a wooden base with a fine grain, with no knots or large flaws. To be sure the wood does not exude sap—which will crack the clay if they contact each other—cure it for about 15 minutes at 250°F. If you are still unsure of the wood, cover it with foil before applying clay, or skip the wood-curing process altogether and just cover the base with foil.

A heavy wire armature was twisted into branchlike coral shapes and covered with foil, then inserted into a lump of clay pressed onto the center of the plaque. A portion of wire was left exposed as a sort of perch on which the seahorse could later rest. The whole armature, including the base (but not the perch), was covered with a $1/4$-inch layer of clay (cut into manageable-size pieces) and the seams smoothed out. To add texture, first a piece of imitation coral was made by impressing scrap clay with the tip of the taper-point Clay Shaper and then curing; this piece of "coral" was then used to impress the coral portion of the sculpture. The entire piece was then baked.

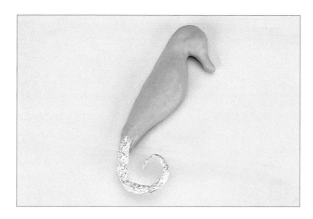

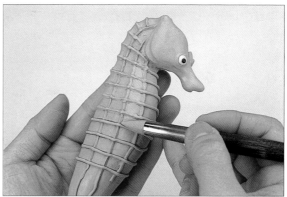

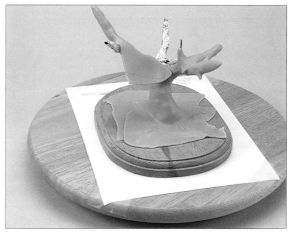

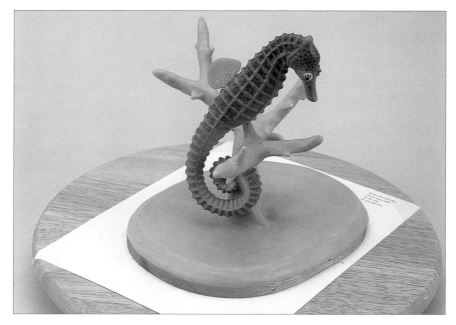

Like all larger sculpture, the seahorse was first shaped out of foil and then covered with a skin of clay. After detail and texture were added, the seahorse was baked. The base was constructed separately from a combination of wood, wire, and foil. Once all curing was complete, the seahorse was placed on its coral perch and can easily be removed.

Realistic Doll's Head

As your skills increase, you may elect to produce more realistic forms. Cernit and Super Sculpey are the polymer clays of choice among doll artists. Both feature a translucent quality that increases the realistic appearance of the finished piece. Some doll artists combine Super Sculpey and translucent Promat to achieve a stronger and more realistic result than that possible with Super Sculpey alone. Cernit, which is used mainly as a "skin" over sculpted heads, is available in three flesh tones; Sculpey is available in one tone only. Fimo's translucent Puppen Fimo is also used by doll makers.

There are numerous methods for making a complex face. I have found that creating from the eyes down works best for me, but you may discover that another method is more comfortable for you. As with other types of sculpture, the armature beneath the clay will help prevent cracking and insure that the clay is completely cured. The doll body may be soft sculpture or composed entirely of polymer clay. Some dollmakers find Super Elasticlay works well for small doll bodies; it's simpler than sewing them, and breakage is minimal with this clay.

1. Working over the end of a dowel, form a head-shaped armature out of foil, binding with masking tape if necessary. Halfway between the top of the head and the chin, create eye socket indentations with the eraser end of a pencil. (See Photo 1.)

2. Apply a uniform layer of clay (I used beige Sculpey III) over the armature. (See Photo 2.)

3. Sink eyes into the sockets. (The ones here are plastic doll eyes from Kemper Enterprises. You can also make your own out of polymer clay, but precure them before inserting into the head.) Add crescents of clay below the eyes and blend. (See Photo 3.)

4. Apply clay above the eyes to form the lids, creating details with a sculptor's tool (a Colour Shaper is used here). (See Photo 4.)

5. Add and blend clay to form the brow bone and cheeks. (See Photos 5 and 6.)

6. For the nose, begin with a cone shape. Flatten it along the back, then pinch it along the top for the nose ridge. Continue working it until you achieve the desired shape, adding indentations for nostrils. (See Photo 7.)

7. Place the nose on the face and blend. The bottom of the nose should be about a third of the way between the eyes and chin. (See Photo 8.)

8. Add clay to define the chin. Place an oblong and a crescent of clay to form the lips. The lower lip should be halfway between the bottom of the nose and the chin. Blend, shape, and refine the mouth. Cure following manufacturer's directions. (See Photos 9 and 10.)

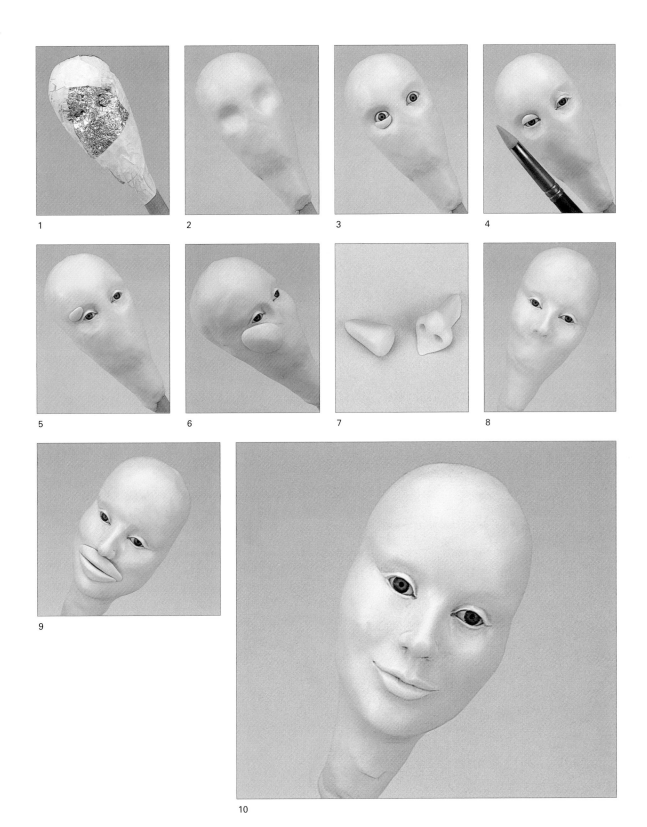

1

2

3

4

5

6

7

8

9

10

Source Directory

Listed at right are the manufacturers and wholesale suppliers for many of the materials used in this book. These companies generally sell their products exclusively to art supply, craft and hobby retailers. A new addition to the source directory is a listing of internet retailers who sell polymer clay and related items through their websites.

If you can't locate a particular product, or if you need special technical assistance, a manufacturer will gladly direct you to a retailer that carries their products, and will try to answer any other questions you might have.

American Art Clay
4717 West Sixteenth St.
Indianapolis, IN 46222
(800) 374-1600
www.amaco.com
Fimo, Fimo Soft, and related items

Houston Art & Frame
P.O. Box 27164
Houston, TX 77027
(713) 868-7570
www.hofcraft.com/houstonartandframe.htm
Mona Lisa products (metal leaf)

Kemper Enterprises
13595 12th St.
Chino, CA 91710
(909) 627-6191
www.kemperdolls.com
Tools, Cernit, and related items

National Polymer Clay Guild
1350 Beverly Road, Suite 115-345
McLean, VA 22101
(202) 895-5212
www.npcg.org
Membership open to all

Polyform Products
1901 Estes Ave.
Elk Grove Village, IL 60007
(847) 427-0020
www.sculpey.com
Sculpey clays

Prairie Craft Company
P.O. Box 209
Florissant, CO 80816
(800) 779-0615
www.prairiecraft.com
Kato Polyclay, books, videos, and related items

Product Performers
4326 Regency Dr.
Glenview, IL 60025
(847) 296-3232
Kato Polyclay, Premo

Ranger Industries
15 Park Road
Tinton Falls, NJ 07724
(732) 389-3535
www.rangerink.com
Perfect Pearls mica powders, embossing powders

Rupert, Gibbon & Spider
1147 Healdsburg Ave.
Healdsburg, CA 95448
(707) 433-9577
www.jacquardproducts.com
PearlEx mica powders

Van Aken International
P.O. Box 1680
Rancho Cucamonga, CA 91729
(909) 980-2001
www.katopolyclay.com
Kato Polyclay, Claytoon Clay, Jazz Tempera

ONLINE POLYMER CLAY RESOURCES
Clay Alley—www.clayalley.com

Fire Mountain Gems—
www.firemountaingems.com

Polka Dot Creations—
www.polkadotcreations.com

Polymer Clay Express—
www.polymerclayexpress.com

Polymer Clay Your Way—
www.polymerclayourway.com

Prairie Craft Co.—www.prairiecraft.com

PUBLICATIONS
Belle Armoire
22992 Mill Creek, Suite B
Laguna Hills, CA 92653
(949) 380-7318
www.bellearmoire.com

Jewelry Crafts Magazine
4880 Market St.
Ventura, CA 93003
(805) 644-3824
www.jewelrycraftsmag.com

Lapidary Journal
60 Chestnut Avenue
Devon, PA 19333
www.lapidaryjournal.com

Polymer Café Magazine
4640 Nantucket Drive
Lilburn, GA 30047
(678) 380-5783

Index